Understanding Human Form & Structure

Giovanni Civardi

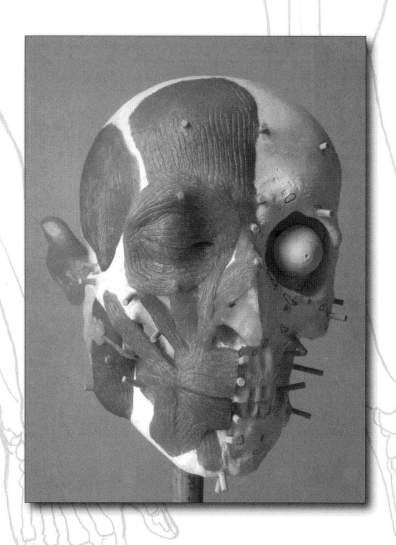

SEARCH PRESS

First published in Great Britain in 2015
by Search Press Limited, Wellwood, North Farm Road,
Tunbridge Wells, Kent TN2 3DR

Originally published in Italy by Il Castello Collane
Tecniche, Milano

Copyright © Il Castello S.r.l., via Milano 73/75,
20010 Cornaredo (Milano) Italy, 2014 *Tavole
Anatomiche*

Translation by Burravoe Translation Services

Typesetting by Greengate Publishing Services,
Tonbridge, Kent

ISBN: 978-1-78221-231-7

The figure drawings in this book are of consenting
models or informed persons. Any similarity to other
persons is purely coincidental.

Printed in Malaysia

Giovanni Guglielmo Civardi
was born in Milan in 1947.
After working in the fields of
illustration, portrait drawing and
sculpture, he has specialised
in anatomy for artists for many
years and teaches human figure
drawing courses.

CONTENTS

Forward from the author

Recently, I made a huge pen drawing of a skeleton. It was
so large that it took five sheets of Ingres paper. It took a lot
of work but it was well worth it because I learnt so much
from it – a good artist never stops learning. I devoted one
sheet to the head (skeleton and muscles), one sheet to the
torso (skeleton), one to the hand from the front (skeleton
and muscles), one to the hand from the back (skeleton and
muscles) and a final sheet to the pelvis and legs (skeleton).

My drawing was inspired by Albert Zahn's manual, called
Esquisses anatomiques à l'usage des artistes (Anatomical
sketches for the use of artists). It contains a number of
illustrations that are very effective and clear, including
details of the hand and foot.

So in this book I decided to do something similar and
complete the drawing of the muscles. This book now
contains the complete figure in the form of the nude, both
male and female, the skeleton and the muscles. In addition
I have included detailed studies of the bones and muscles
of the head, torso and limbs, in front (anterior), side (lateral)
and back (dorsal) view.

In the future, I plan to get hold of anatomical illustrations
of animals, such as a horse, cow and sheep, from a
veterinary school, and then draw them in the same way as
I have approached the anatomy of the human.

There are laws of proportion, of light and shadow, of
perspective, and so on, that one must know in order to
be able to draw anything realistically. If one lacks that
knowledge, it will always remain a fruitless struggle and one
will never give birth to anything. That is why, I believe, I'm
steering a straight course by following this direction of study.
It will help my understanding and therefore my drawing
abilities, and I hope it will help you too. In the words of
Vincent van Gogh, 'Drawing is a hard and difficult struggle,'
but with perseverance, as an artist you can fly.

The nude studies in this book are of consenting models
and any similarity to other individuals is purely coincidental.

INTRODUCTION

 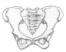 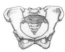

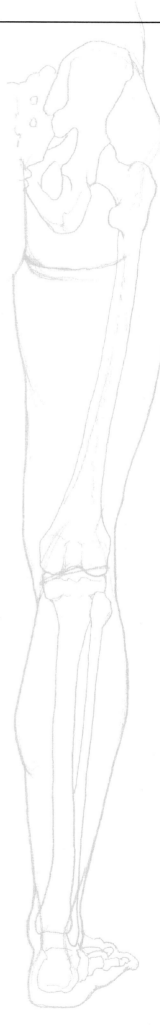

The artist uses the study of anatomy in order to understand and depict the shape of the human figure. Teaching in most art schools is founded, primarily, on the in-depth study of the human figure. This is because, in order to draw the human form effectively, you not only need to be able to see the form that you are drawing but to understand it.

The human body is such a complex and intriguing structure that, in order to depict it effectively, a high degree of understanding is required, and this is acquired through preliminary anatomical study*. In the end, the primary job of so-called 'artistic' anatomy is to clarify the complexity of the human figure for the artist and allow him/her to depict it in the most convincing way. This includes interpreting the features according to expressive or aesthetic criteria. It is therefore very important for the artist's technical and cultural training that he/she gains an awareness of the structure of the body – its 'anatomy' – and understands the mechanisms by which its parts relate to one another.

It is easy to understand how examining the external forms (the ones that the artist is most interested in) is greatly simplified if we are familiar with the internal structures and how they influence the outer appearance. But it is also true that the approach adopted in modern art, and especially in contemporary art, does not focus on the objective, realistic body form (at least not in the classical way) and, consequently, courses sometimes ignore or refute the in-depth study of anatomy for the artist, practically relegating this method to obsolescence. And yet, the ancient origins and complex historical development of this discipline sanction the value of anatomical study in the arts today if it is understood as a tool to gain knowledge, a resource shared between scientific and artistic vantage points. In other words, anatomical understanding does not constrict the artist's freedom of expression. On the contrary, it stimulates it to move towards various and far-reaching pathways of research or creativity.

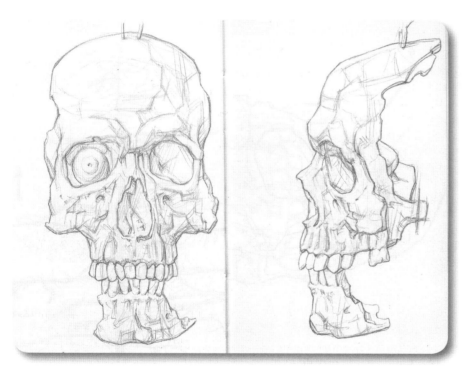

Pages from a sketchbook (2007).

* This short book covers the basics of anatomy for the artist, but if you wish to take your studies further, I suggest you refer to some of my other books on the subject such as *The Nude, The Human Form* and *Complete Guide to Drawing*.

1 THEORETICAL AND PRACTICAL CONSIDERATIONS

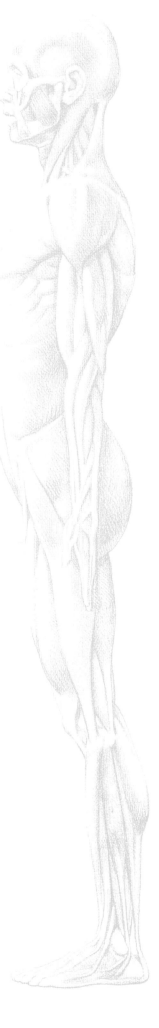

The topic of study

Delacroix said that the artist should learn anatomy and then forget it. Although it may seem odd that I have mentioned this here, it does highlight the point that the study of anatomy should be regarded as a tool and not an end in itself. A deeper knowledge of anatomy should not be flaunted and deployed as an erudite execution of drawing; rather it should be at the service of art, present in the background, mastered so well as to achieve simplicity, a seemingly natural flow that works to make the result even more convincing and lifelike than the figure it represents.

Until the beginning of the 20th century (and sporadically even after that) it was considered essential for western artists to have an in-depth knowledge of human and animal anatomy because the dominant and accepted aesthetic styles called for an 'academic' approach. In other words, artists were expected to paint and sculpt in a way that was extremely faithful to the object and to nature. However, it is also true that many of the tools now available for the investigation of anatomy and morphology, which have often substituted the study of cadavers, were not available then (and they were not available to physicians either). Just think, for example of x-rays, CAT scans, Magnetic Resonance Imaging, digital scanning, computerised three-dimensional reconstructions, etc.

In the Ancient West, and later at the apex of the Italian Renaissance, the virile body was considered the archetype of the human being. The curious dominance of the male figure over the female one and the references to classical models were also reflected in artistic teaching and in the illustrations that accompanied anatomical investigations, at least almost until modern times. To the Ancient Greeks, for example, the ideal body was that of the 'victorious soldier', nude in its power, a symbol of accomplished virility and with a noble social function. To this ideal motivation, over time, other reasons, which were socially or religiously convenient, or ones that were purely practical were added. For example, the male body (more than the female one) usually has a visibly heavier muscular structure and for centuries the cadavers available for dissection according to applicable laws were mostly those of criminals and vagabonds, with a large prevalence of males.

Traditional anatomical studies, in the way they developed, layer by layer over the centuries, are still valid today and will remain so for a long time, despite the increasingly widespread possibilities of changing appearance, and functional or plastic remodelling of the human form (additive or integrative prostheses, organ or body-part transplants, plastic surgery, exo-frames, bio-electronic or genetic integration, android robots, etc). Our own species, Homo sapiens sapiens, dates back thousands of years and it seems that in all that time, the human body has not undergone significant changes. All in all, technological changes in health and mobility aside, there is no real reason to think that our body will change its form radically in the near future: the man of the future will above all gradually adapt to new environments and new intelligence, finding new ways of making biological and technological perspectives co-exist.

Sources of study materials

The dissection of cadavers This is the most traditional method of investigation. For centuries this practice has brought artists and doctors together, in their common need for knowledge and reflection but it has now been almost totally abandoned, even in the formal training of doctors, and substituted by other means of visual exploration. It is obvious that the appearance of a cadaver is quite different from that of a living person and thus the artist's interest is limited merely to in-depth topographical knowledge, and above all, the intense emotional experience.

A skeleton, assembled and jointed This can be a real skeleton, but is more often an artificial one, faithfully constructed using plastic casts of the single natural bones joined together to make a complete bone structure. The full artificial skeleton (or individual bones) is available for purchase, but is quite expensive, so it is cheaper to use the ones that can be found in medical or art schools where they are certain to be available for study.

Real skeletons are almost always on display in museums of natural history. The jointed and assembled skeleton is held in an upright position called the anatomical position (see page 6) using a suitable metal stand, but it can be positioned in any posture that simulates a natural one. We should bear in mind, however, that the joints (especially the limbs) can take on positions relative to each other that do not correspond to the natural ones due to gaps between

the ends of the bones, absence or presence of obstacles to mechanical movement, absence of cartilage and ligaments (which have been substituted by metal screws) and so on.

Anatomical illustrations These may be in the form of drawings, diagrams or photographs, x-rays and computerised reconstructions. It is quite easy to collect this type of reference over the Internet, visiting the educational sites of medical universities or art colleges. The Visible Human Project contains an atlas that is especially resource-rich and useful; part of this is available on the Internet.

Three-dimensional models This group includes statues of muscular structure, anatomical wax models, plaster casts of anatomical preparations, plastic models, etc. Illustrations are two-dimensional, follow certain graphic conventions (regarding lines, colours, illumination, etc.) and can be deceptive with regard to volume, so three-dimensional anatomical models are an essential supplement, helping the artist to visualise body forms correctly. The best and most widely known muscle-structure statue in art schools is the so-called 'skinless' statue by Houdon (two versions exist). Much smaller and cheaper scaled-down plaster models are available for purchase. Anatomical wax models have a glorious history. The best ones were made in the 18th and 19th centuries, and can be found in museums (for example, La Specola, in Florence).

Life models The artist needs anatomical knowledge to draw the nude better, understand it and give it expressiveness. Observing a model allows us to identify and recognise the living anatomical bone and muscle structures and their relationship to external forms, both when they are stationary and moving, drawing the correct distinctions between the two sexes, the different ages, and the different constitutional types (see pages 12–15 and 19).

What to look out for

Regarding the skeletal structure Look at the general shape; volumetric, proportional, and axial ratios for its principal parts (axial and appendicular skeleton, see page 22); the shape of the end of the bones and the mechanism of the mobile joints; the thickness, diameter, profile and length relative to the main bones; the volume of the complex forms (cranium, thoracic cage, hips, etc.) but considered as a united form and structure and not as the single parts that make it up. Overall, for our purposes, it is not necessary to study the individual particulars of each bone. All we need is a summary impression of the skeleton taken as a whole, in its function as the weight-bearing structure of the entire body, at least in the three common views of descriptive anatomy (frontal, dorsal and lateral – front, back and side). It is, however, important to study and memorise the ratio of the dimensions of adjoining bones, the proportions with respect to each other and the whole skeleton, etc. because this information is practically indispensable to the ability to 'interpret' the figure on paper and to achieve the skill to change it coherently and significantly.

Regarding the muscles Consider the location, position, and how you can find the insertion and origin tendons of the muscle you are considering (see page 34); its development and the principal axis of the muscle belly; its shape when it is at rest and the increase, if any, in its volume when it is contracted; its prevalent function, its physical relationship with other deep and adjacent muscles, etc. In the case of the limbs especially, the muscles should be considered as complex masses, groups of muscles rather than as single elements. When observing shapes of living models it is useful also to consider the thickness of the integument (skin, fat, superficial veins, etc.), which is layered over the muscular component, and the fascia that covers it all.

How to draw

All shapes can be simplified into geometrical forms, flat or solid. Imagining a form in terms of geometrical shapes helps to give the drawing substance as well as a volumetric (i.e. three-dimensional) quality. The characteristics of 'anatomical' design, interpreted by the artist for aesthetic purposes, are different from those done for scientific illustrations. The standard tools can be used, whether for drawing (charcoal, ink, pencil, coloured pencil, etc.), painting (oil, gouache, watercolour, etc.) or sculpting (clay, wax, etc.). Your art piece can be inspired by a model (living or in a photograph), done from memory or copied from a three-dimensional work of art. It can be made with any number of intentions in mind and it can be done analytically, synthetically, schematically or in the form of a diagram (see page 10).

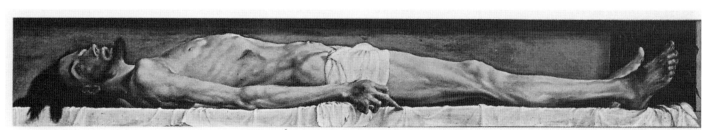

The Body of the Dead Christ in the Tomb (1521–22) *by Hans Holbein the Younger, oil on limewood (30.6 × 200cm/ 11¾ x 79in),* Kunstsammlung Nordrhein-Westfalen, Basle.

2 BODY BASICS

First let's talk about viewpoint and pose. For the purposes of the study of the human form, the figure should be viewed in the position that is most natural and typical – standing with the upper limbs extended along the trunk with the palms of the hands turned forward and the lower limbs with the heels pulled together. This is known as the anatomical position and is chosen as a convention. In this position the observer can see the body's anterior (front) view, dorsal (back) view and the two lateral (side) profiles. The anterior view highlights the normal (though not perfect) bilateral symmetry, in which the right antimere (half) is the mirror image of the left along the mid-sagittal (median) plane. It shows the cross sections (which are parallel to each other in this view) at the level of the shoulders and hips, the volumetric ratio between chest and abdomen, the axes of the lower limbs, and the relevance of proportion and of constitution (see pages 16 and 18). Lateral (side) views allow us to establish first and foremost the body's line of gravity (see page 18), which normally, in the frontal view, passes along the medial plane of symmetry (straight down the middle), and falls within the area of contact with the ground (represented by the feet). From the side, the line of gravity can be projected onto a vertical line that passes from just in front of the ear hole through to the lateral malleolus (the outer ankle bone). Here again, a side view allows us to see the front profile of the torso, the curvature of the neck and back, and the muscular and adipose texture of the abdomen, buttocks and thighs.

The body systems

The human body, like that of the other superior vertebrates, can be broken down into several systems, or complexes of organs that together carry out a specific function, such as the digestive system, the cardio-circulatory system, the nervous system, the reproductive system, etc. One such system is the locomotor or musculoskeletal system, which gives us structure and the ability to move. Made up of the bones, muscles, tendons, ligaments and so on, it has a major effect on the shape of the body. For simplicity this can be subdivided into three – the skeleton, the joints and the muscles.

- The skeleton provides support and protects the internal organs. It can be further divided into the axial skeleton of the head and torso (cranium, vertebral column, thoracic cage) and the appendicular skeleton of the limbs. These systems are connected to each other at the shoulder girdle and hip girdle.

- The body's system of joints is known as the articular system. It is made up of elements that join single bones, keep them in place and permit body movements, activated by the contraction of muscles.

- The muscular system enables voluntary movement of the various body parts. The muscles can be grouped into deep, intermediate and superficial muscles, and of these, it is the superficial muscles that have most direct influence on shaping the external body contours. However, the underlying muscles still have a visible influence in building the volume of the body.

The general form of the body is determined by the skeleton, which is the basic weight-bearing structure, by the muscles that are laid onto it and the adipose layer (fat) that covers it. Fat is distributed all over the body in layers of varying thickness, just below the skin. Its presence, quantity and location influences the external form of the body and is related to individual characteristics (age, nutrition, health, sex, racial group, etc.). The consistency, extent and location of areas where fat is deposited are slightly different in men and women, the most recognisable and predicable ones being the chest/breasts, the umbilical (tummy), pubic, gluteal (buttocks), subtrochanteric (upper thigh), rotular (front of knee), popliteal (back of knee), super-iliac (hips), cervical (neck) and retro-deltoid (shoulder/upper arm) regions.

Fat, or adipose tissue, is part of the integumentary system, which protects the body from damage, abrasion, loss of water and so on. The integumentary system includes the skin and associated tissues – hair, nails, fat and, in the case of birds and animals, also feathers, hooves and scales. Together with the elements of the locomotor system described above (skeleton, joints and muscles) the integumentary system is of most interest to the figure artist. The way these parts are organised allows the body to maintain a relationship with its surroundings – to keep itself erect and move in space.

Simplifying into geometrical shapes

The body is made up of the head (an ovoid), the neck (a shaped cylinder), the torso (a cuboid) and the upper and lower limbs (a series of shaped cylinders).

The head and neck The head has two distinct parts: the cranium and the face. The cranium is ovoid, with a longer axis in the front to back direction, rather flattened at the sides and in front (forehead). This is the skull, formed by thin bones fused together, which houses the brain. The other part, lower down and in the front, is the face or the facial block, also made up of tightly connected bones as well as a mobile joint, the mandible or lower jaw. On the head are many thin muscles whose function is mimicry or facial expression and other thicker muscles whose function is masticatory (chewing), as shown in the drawings on page 43. On the head as a whole, but especially on the face, we can see some characteristics that distinguish groups of human beings and the sexes, for example facial hair (beard and moustache) that only adult males have, or the smaller size and more delicate structure of the female skull as compared to the male one. There are also small but numerous individual differences in general form and single details (eyes, ears, nose, lips) which we are used to observing as they allow us, principally, to identify people. There are also a considerable number of modifications that set in gradually in individuals as a result of age, nutrition and behaviours/habits as life progresses. For example, the very low face of children as compared to that of a young adult becomes low once again in the elderly following the narrowing of the lower jaw and the loss of teeth (an effect that is countered in real life by the use of suitable dentures). Likewise the rounded face found in young, well-nourished people, becomes lined and wrinkled in the elderly due to the reduction of subcutaneous fat and the loss of skin elasticity.

The neck is almost cylindrical, or, more precisely, it is in the shape of a truncated cone, somewhat flattened from the front and back, with the larger base on the torso. It appears slimmer or squatter depending upon the position and shape of the shoulders and their relationship with the muscles of the area. Its bone-structure support comes from the cervical part of the vertebral column, which is fairly flexible in its movement of flexion, extension and rotation (see page 32). Around this there are many muscles whose job is to help the head move. Just below the skin, on the sides of the neck is the platysma, a thin, broad muscular sheet that rises up from the collarbones whose contraction sometimes causes long thin skin grooves in an oblique direction.

The torso The back of the torso is flat (a characteristic of the human species) but it is not perfectly flat, especially in the lumbar region, at the height of the abdomen, where a slight convexity can be observed in a transverse direction and greater concavity in the vertical direction.

The primary skeletal support structure of the trunk is the vertebral column or backbone. Viewed from the front it is perfectly straight but viewed laterally it shows a series of curves corresponding to the different regions (cervical, thoracic, lumbar and sacral): those that curve outwards on the back are called kyphotic; those that curve inward are called lordotic (see page 33). On the back, below the large topmost muscles whose main function is the movement of the upper and lower limbs, it is easy to see portions of the skeleton that are close to the surface (for example, the shoulder blades, the vertebral processes, the ribs and the iliac crest). In the different body parts it is easy to identify areas on the surface, where limited portions of the bones are just under the skin and thus stick out to a greater or lesser extent, under thin, taut skin. These so called 'anatomical landmarks' can be easily felt and seen in all individuals, even when there is a lot of fat, and in both sexes. They are very useful reference points for depicting the human body and serve to evaluate or verify the overall proportions or those of individual parts because their location is fixed and independent from the model's position or type of physical constitution.

Seen from the front, the torso can be divided into three sectors: the thorax (from neck to abdomen, including the ribcage), the abdomen and the pelvis (hips). Note that the external dividing line between the abdomen and the thorax is not the same as the internal one. The skeletal portion of the thorax is made up of twelve pairs of curved bones or ribs, which join to the vertebrae at the back and the sternum at the front; its external lower end matches the lower part of the ribcage (known as the costal arch), while the internal limit is much higher as it corresponds to the cupola of the diaphragm muscle. The shape of the abdomen, where there are no ribs (skeletal support is provided only by the lumbar portion of the vertebral column), is determined by three factors: the width of the higher skeletal ring formed by the lowermost ribs in the ribcage and that of the lower skeletal ring, meaning the pelvic girdle where the lower limbs are located; the volume of the organs contained in the cavity; and the muscle tone between the two skeletal rings, that is, the abdominal muscles, which oppose the push of the bowels against the abdominal walls. In males the abdomen is cylindrical and in females it is somewhat wider at the bottom (because of the wider hipbones), while in children it is wider at the top. In plump people, it is round, protruding

and sagging to a greater or lesser extent. The collarbone and shoulder blades, as well as protuberances of the iliac spine can be seen on the surface of the trunk, while the ribs and costal arch are usually less visible. The surface muscular structure of the thorax is made up large, wide muscles, the large pectorals and serratus anterior muscles, the abdominal muscles from the rectus abdominis (abs and lower abdominals) and the external oblique muscles. The pelvis is largely hidden by the muscles that work the legs.

Many variations in the torso that are due to sex, ethnicity and age depend on the degree of muscular development, differences in skeletal structure and the quantity of subcutaneous adipose tissue, which can obscure the skeletal form underneath. Important sexual differences can be seen in areas of the chest and hips, the latter being typically wider in women, as well as by the distribution of body hair.

The limbs The thoracic limbs (arms) and the pelvic limbs (legs), although adapted to different functions, are evidently constructed in a similar way. Moving from the torso outwards to the free end, we have, respectively, the shoulder and the hip, the upper arm and the thigh, the forearm and the calf, the hand and the foot, the fingers and the toes. The first difference we might notice is that the shoulders are very mobile, while the hips and pelvis form a composite unit that is solidly fixed to the lower part of the vertebral column and so is less mobile. The arm generally has a greater degree of mobility in relation to the shoulder than the thigh in relation to the hip. The elbow joint of the arm corresponds to the knee joint in the leg, but bends in the opposite direction. The wrist, positioned between the forearm and the hand corresponds to the ankle (talocrural joint) but, while the longitudinal axis of the hand directly continues that of the forearm, the foot joins the leg at a right angle so that the sole (corresponding to the palm of the hand) can rest on the ground.

Each shoulder is essentially made up of a large muscle (the deltoid), which works by moving the entire limb. It is visible as a rounded outward protrusion, raised or sagging depending on the width of the upper chest. If the arm is pulled away from the trunk, the bottom side of the shoulder (which previously, in the anatomic position, was just a furrow) appears as an indentation (the armpit or axilla). Anatomy students use three imaginary lines running straight down beneath the armpit to aid the location of body parts. The one at the front is the anterior axillary line, the one dropping from the back of the armpit is the posterior axillary line, and the one in the middle is the midaxillary line. The anterior line is principally made up of the pectoralis major muscle, the posterior one by the teres major and latissimus dorsi muscles.

The arm is somewhat cylindrical in women and children, while in males who have projecting muscular development (the biceps on the front, the brachialis on the side, the triceps on the back, etc. arranged around the humerus), it is quite flattened in a cross section. The elbow, instead, is widened and at this location the axis of the forearm continues that of the upper arm, but with a slight deviation, forming an obtuse angle when viewed sideways.

The forearm has the shape of a flattened cone in a front-to-back direction and is narrower towards the hand. Its muscles are arranged around two bones, the ulna and the radius, and are divided into two groups: one is the flexors of the hand and fingers, located anteriorly and medially, and the other

is the extensors, located posteriorly and laterally. The tendons of the flexor muscles are very noticeable at the level of the wrist, while the extensors are seen only on the back of the hand. Characteristic networks of superficial veins are also visible on the front of the forearm and the back of the hand.

The wrist widens when it reaches the hand but remains fairly flat and slightly concave on the front side (the palm) and slightly convex on the back of the hand. The palm also appears concave due to the presence of two muscular projections, united at the top towards the wrist and divergent at the bottom, where we can see a third, transversal ridge, which this time is cutaneous and adipose. The elevation on the side, at the base of the thumb, is called the thenar eminence, while the medially situated one (base of the little finger) is called the hypothenar eminence. The five fingers can move independently from the hand in almost all directions and are made up of segments known as phalanges, joined to each other in such a way that they can only bend with respect to each other. The thumb has only two phalanges as the central one is missing (while all the fingers have three) and, when it moves sideways away from the hand, the thumb can make a movement opposing each of the other fingers. This mechanism is responsible for the prehensility (grasping ability) of the hand. The nail plate, a loosely connected horny plaque is inserted in to the lower half of the back of the last phalange on each finger.

The lower limbs are longer and thicker than the upper ones. The hips and pelvis are hard to tell apart and are posteriorly and laterally covered by the gluteal muscles. The thighs have the shape of an upside down truncated cone; around the femur, there are large muscles from three functional groups: leg extensors, placed anteriorly; flexors, placed posteriorly; the adductors, placed medially. The leg is joined to the thigh through the knee joint and makes an obtuse angle to the side relative to the thigh, somewhat wider in the female in proportion to the width of the hips. It has a cylindrical or truncated cylindrical shape, more voluminous at the top, where it has a wide cross section.

Posteriorly, the wide, vertical calf muscle juts out. The muscles are arranged around the two parallel bones of the calf, the tibia and the fibula, divided into an anterolateral group, which acts to flex the back of the foot, and a posterior group, which acts to flex the sole. The ankle is quite slim, wedge shaped, and placed back with respect to the large Achilles tendon; medially and laterally, it displays the asymmetric malleolus projections (ankle bones).

The sole of the foot corresponds to the palm of the hand. Here we can see a rounded posterior projection, the heel, a raised section on the outer edge (lateral plantar) and the ball of the foot (medial plantar). The sole rests on these projections, but remains elevated in the centre and medially on the side of the big toe, the extent depending on whether the foot is normal, arched or flat. The top of the foot is convex and here we can see quite clearly the tendons of the toe extensor muscles and some superficial veins. The foot has five toes, which though comparable with those of the hand, are noticeably shorter and less mobile and all stretch out from the far end of the foot. With the exception of the big toe, all the toes are curved and concave on the underside. They are counted from the centre of the body towards the outside, but only the first one, the big toe or hallux, has a name. It is much larger than the other toes and is separated from them by a large gap; it cannot oppose them.

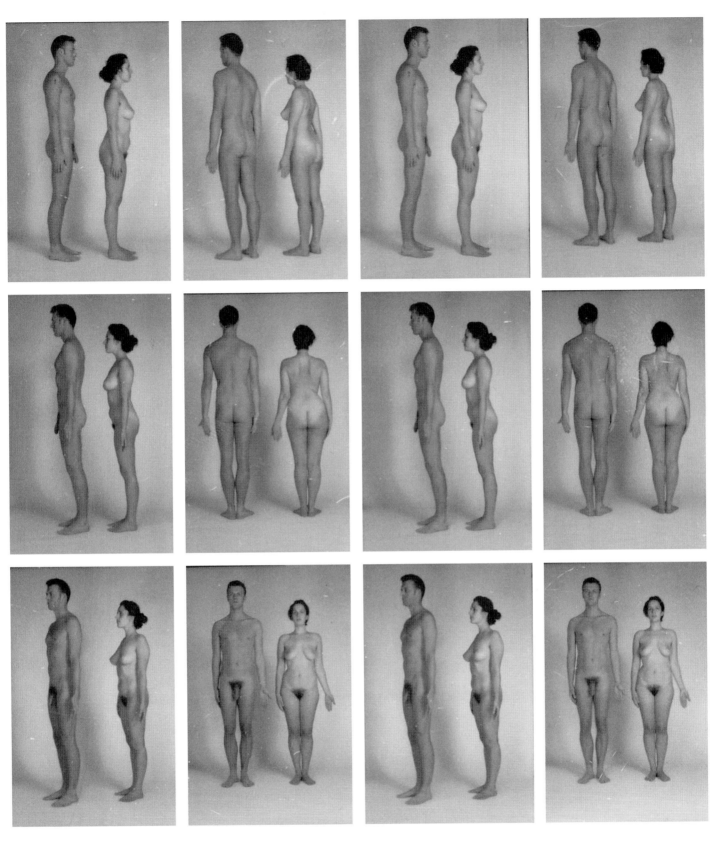

These figures are standing in the anatomical position (see pages 13–15) and are viewed from various angles. These images are useful for an analysis of proportion.

3 ANATOMICAL DRAWING METHODS

Anatomical drawing done by an artist is different from scientific, documentary or descriptive drawing because its main purpose is to explore the shapes of the body parts, their volumes, proportions, structure and shading.

The artist's procedure for drawing (or sculpting) the human body is guided, therefore, by aesthetic and compositional criteria, which although based on objective data, is then interpreted and adapted according to the emotional, expressive and cognitive aims of the artist, unique to each artist*. We can choose between two traditional, classical procedures – the tonal or the linear – or find a combination that integrates both approaches to varying extents. These procedures were inspired by academic teaching principles ('first the line, then the tone'), which suggested that the outlines of the figure should be drawn first and then the tonal modulation inserted. Although this indication has been in contrast with the modern vision of aesthetics for some time now, these methods still offer some worthwhile benefits for teaching and learning.

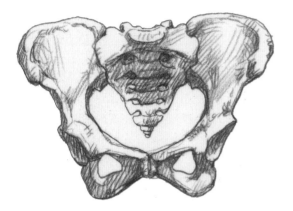

Linear drawing This is what you may have started doing as a child: drawing the outlines of the subject, with no reference to colour or tone. This type of drawing leads to a certain degree of abstraction, and the omission of many details helps us to analyse, above all, the relationships and proportions of the body parts rather than the volume and characteristics of different tissues (bone, muscle, tendons, etc.). Suitable tools are pen and ink, hard graphite pencil (H), felt-tipped pen, ballpoint pen etc.

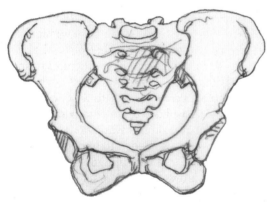

Tonal drawing In this case the subject is observed and expressed only in terms of its tone – areas of light, mid-tone and dark – to create a very three-dimensional form. This is all about the volumes. The tools suited for this type of work are charcoal, chalk, medium-hard graphite pencils (HB, B); coloured pencils, monochrome watercolour or wash (ink diluted with water) etc.

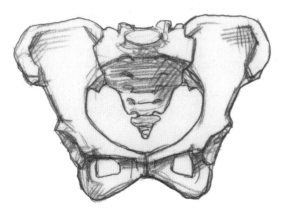

Mixed drawing This is the middle way, combining line and tone in an intuitive and sensible way that is aesthetically effective and imparts information efficiently. All the traditional tools (graphite pencil, charcoal, ink, etc.) can be used to add some tone to a linear drawing.

* Today's anatomical illustration makes use of complex graphic-design programmes which can take apart and put together the different body parts, separating their structural components as well as rendering their three-dimensional structures. These are, however, procedures that do not belong to classic artistic research (though they can support and inspire it) and more correctly belong to the field of scientific and didactic investigation.

Some types of anatomical drawing

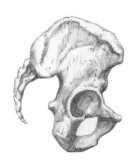

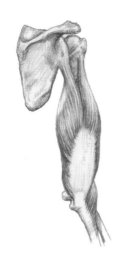

Analytical drawing This drawing style aims to produce an objective, naturalistic drawing of anatomical shapes. Here, all the important details are usually depicted with meticulous fidelity to the original (and with attention both to 'what you see', and to 'what you know should be there'), according to the chiaroscuro effects produced by the type of illumination that has been chosen to make the picture appear clearly.

Sketching or reference drawing For the most part, anatomical drawings made by artists for practice and study are, in a manner of speaking, filtered: the basic elements of form are shown or accentuated, while the secondary details (or what the artist deems to be secondary according to his purpose) are omitted or given minor importance.

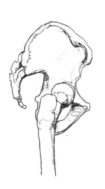

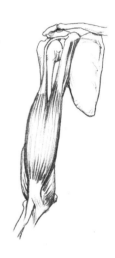

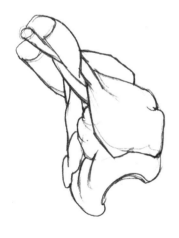

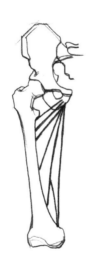

Schematics or diagrams It is now rare for an artist to draw (or even want to draw) his/her subject from real life (a cadaver, a natural skeleton, anatomical preparations, etc.). Almost always, he/she works by deducing the skeletal and muscular structures from the external forms of the (living) model. The schematic drawing is therefore useful visually to describe the constructions that have been learnt, for example, from anatomical atlases. In this way, attention is on the essential elements needed to understand the exploratory 'path' (not very differently from a topographic map), extracting only what is needed from the usual aspects of form, volume and colour.

Construction drawing This type of strongly geometrical map has been developed recently and visualises the human body like a machine, investigating its mechanical and architectural components. It is not very differently from what is shown in design and planning schemes for any complex object.

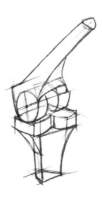

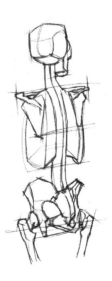

4 MORPHOLOGY: EXTERNAL FORMS

The study of body systems is a traditional element of descriptive anatomy, and morphology, or the study of form, is an essential complement to this discipline. We have already referred to external forms but now it is also useful to consider that a lot more information is available in the linked sciences of anthropology and anthropometry. Before your eyes glaze over, you should know that these scientific disciplines would have been studied as far as possible by the great artists of the past, such as Leonardo da Vinci. They include study and analysis of body characteristics in relation to sex, age, geographical provenance, human groups, climatic adaptation, etc. By referring to information in the form of books or websites designed for the study of these disciplines, it is simple (for the artist who wants to study anatomical information and find inspiration) to gain awareness of many differing features regarding apparent forms of the body, such as the colour of the skin, the distribution of body hair, the shape of the head and face, height, physical structure (see page 18), the distribution of adipose tissue, etc. The sketches below and on the next three pages highlight some physical characteristics that vary in specific ways between adult men and women. By considering the reasons behind the differences, an artist becomes more knowledgeable and confident in drawing congruent and anatomically credible figures.

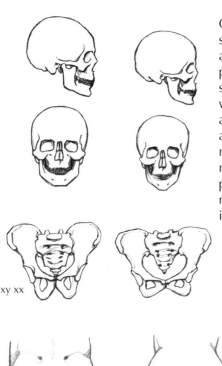

xy xx

Compare a typical male skull and pelvis (far left) and a typical female skull and pelvis (left). A woman's skull is slightly smaller (in accordance with the shorter stature), the angle of the mandible (gonial angle) is wider, the orbits are more circular, the forehead is more vertical, etc. The female pelvis is wider, shorter and more inclined, as is also shown in the sketches on the right.

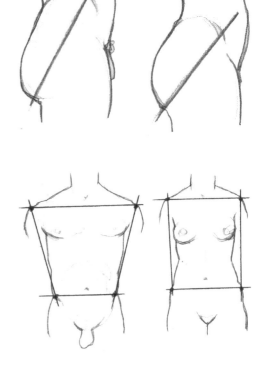

In the lumbosacral region (the lower part of the spine where the lumbar and sacral segments meet), we can almost always see slight symmetrical indentations at the position of the superior and inferior iliac spine of the pelvis, which manifest on the surface as the dimples on the lower back. There are four in men (above left), two upper and two lower ones; and in women (above right) there are only two, the lower ones, which slighter further away from each other because of the wider female pelvis.

The diagrams above compare the standardised torso of a male (above left) and female (above right). As well as the different pelvic width there are also some characteristics that are part of so-called sexual dimorphism and which are especially important in order to understand the human form and to draw it artistically and convincingly. For example, the male skeleton is bigger and more robust overall, the sternum (breastbone) is longer and less slanted, the distance between the rib cage and the pelvis is shorter, the arms are proportionally longer with respect to the torso, the total torso length is proportionally shorter and the 'centre' of the body corresponds to the pubic symphysis (the midline joint between the two rami of the pubic bone) while in the case of the female it is located slightly higher).

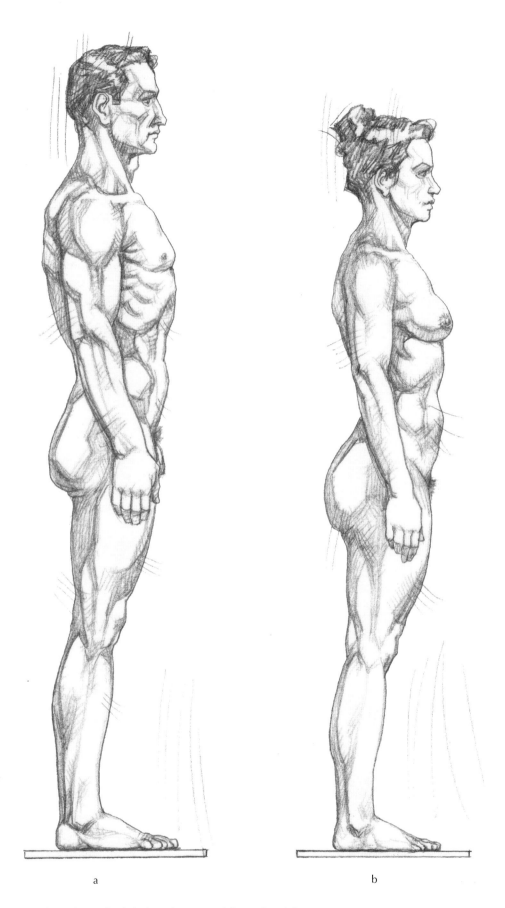

a b

Comparison between an adult male and adult female viewed from the side.
(See the corresponding photograph on page 9.)

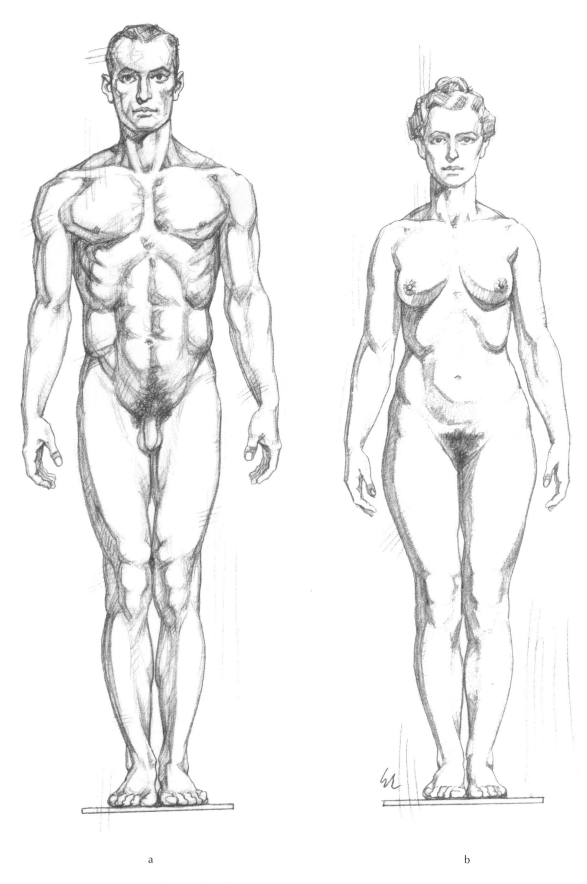

a b

Comparison between an adult male and adult female viewed from the front. There is an obvious height difference, but this is not only a sexual characteristic. Height is also related to age, health, racial group, standard of living and so on. With respect to the average height of a fully grown male (about 175cm or 5ft 9in tall), the average female is about 10cm or 4in shorter.

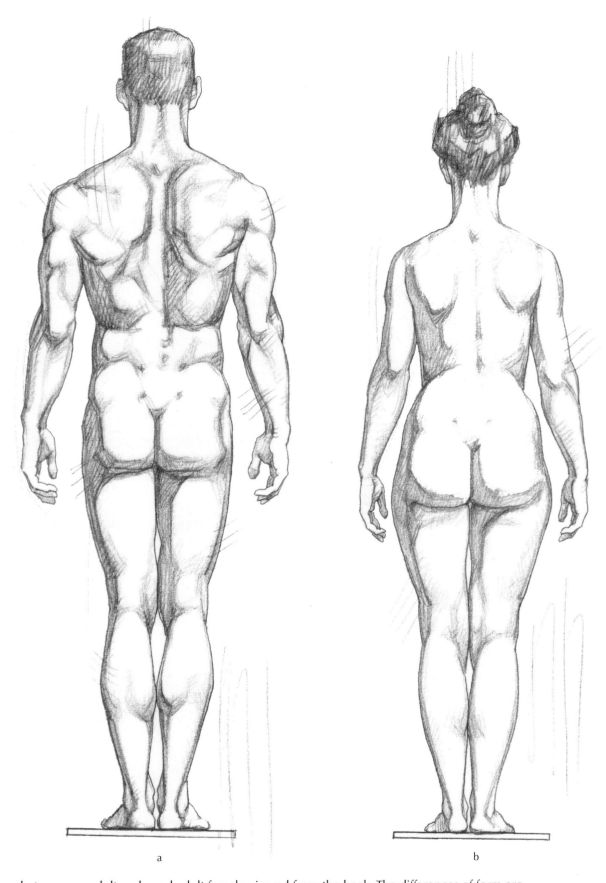

a b

Comparison between an adult male and adult female viewed from the back. The differences of form are as distinct and obvious in these examples as they are from the front.

5 PROPORTIONS

The length of the head, from forehead to chin, is often used as a unit of measurement for assessing the proportions of body height. In a standardised body, the total height is about seven and half heads. Other proportions follow on from this, which are useful to remember: the neck and the trunk together are three times the head length; the maximum distance between the ends of both shoulders is two heads; the upper limbs are three heads long; the lower limbs are three and a half head lengths, and so on. These rules refer to a standardised individual, not a real one, and actually the proportions used by the artist will be inspired by stylistic, cultural and aesthetic ideas. Often a more pleasing rule of proportion is preferred, making the body eight head lengths.

Note that the proportions just given only apply to adults. Body proportions change as a child grows until it reaches adulthood, and again you can find charts recording the standardised proportions for each stage. For example, at birth, the head is proportionately very large, the abdomen very round and the limbs (especially the legs) very short. The body of a two-year-old child can be divided into four parts of equal length: the first one includes the head and neck, the second the chest and abdomen, the third the pelvis with hip and thighs and the fourth the lower legs and feet.

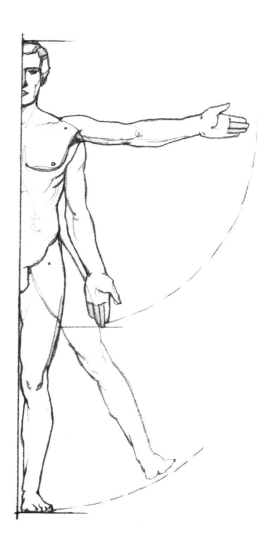

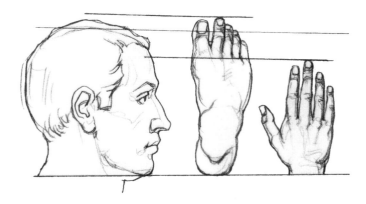

The length of the hand is equal to the height of the face, measured from the base of the chin to the hairline on the forehead; the foot is a little longer than the whole head and almost a third longer than the length of the hand.

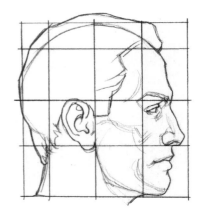
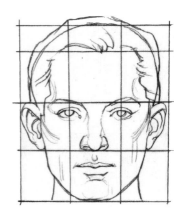

This diagram shows the angle of movement of upper and lower limbs. A similar drawing was famously made by Leonardo da Vinci (*The Vitruvian Man*). It is interesting to note that the maximum arm span with both arms extended corresponds almost exactly to the body height.

The face can be divided lengthways into three equal parts that correspond to the height of the forehead (up to the hairline); the full height of the nose; and the height from the bottom of the nose to the chin. The relative ratios of the other features (eyes, lips, ears, etc.) can mostly be deduced from the grid in the drawing, and apply also to the female face. The distance between the eyes equals the width of each eye. Note that the proportions can differ according to age and genetics.

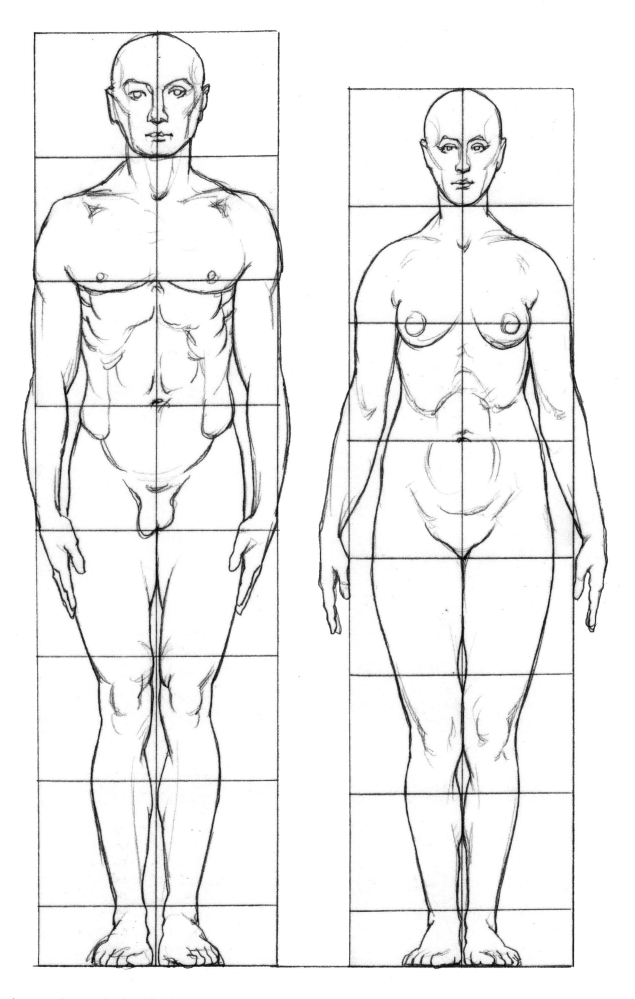

Diagram showing the standardised body proportions estimated according to natural criteria that call for the division of body height into seven and a half measures (head lengths) both in men and women.

6 OVERALL BODY STRUCTURE

Although we can all easily identify major body parts (head, forehead, neck, abdomen, thigh, leg etc.), a deeper understanding of the form and function of all the body parts, and the ability to name them correctly, enriches the artist's understanding and expressive ability. Also, providing appropriate terminology allows for efficient and unambiguous dialogue with other scholars of the same discipline. If scientific notions become common knowledge, this does no harm to the freedom of expression in art.

The overall body structure has already been summarised in chapter 2 (see page 6). Here we will look at useful terms to describe viewpoints and body planes and take a quick look at the three basic body types.

To avoid confusion, all the anatomical terms are conventionally used to refer to the human form when standing in an 'anatomical' position', with the heels together and the palms of the hands turned forwards, as shown below left. All the descriptive terms of position and movement are based on this position, as are the imaginary planes that are useful for identifying the location of body features, such as the sagittal and coronal planes. These planes, explained below, enclose and divide the space occupied by the body.

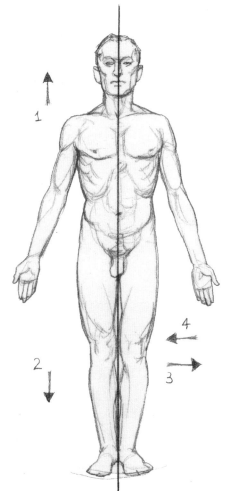

The median or sagittal plane divides the figure in half down the middle, down the line of the navel. It is shown here as a black line. The top or upper portion of the body or a bone, for example, is called superior (1); the lower portion is inferior (2). When it is to the side it is lateral (3) and to the centre it is medial (4) – compare medial malleolus (the ankle bone on the inside of the leg) and lateral malleolus (the ankle bone on the outside of the leg). The front is the anterior and the back is the posterior.

To understand the volumetric structure of the human body, or of any other object or construction, we can refer to the three conventional viewpoints – frontal, dorsal and lateral (front, back and side) – and by using cross sections it is easy to derive all the numerous variations of perspective orientation and body position.

In the lateral (side) view, the axis of equilibrium (axis of gravity) of a person in the standing position can be easily identified (see the diagram, right). This is a line projected onto the lateral plane, passing right in front of the pinna (outer ear) and through the lateral malleolus (outer ankle bone) and which we can imagine running vertically through the body in a straight line until it goes into the ground within the standing area (marked by the outline of the feet and the area between them).

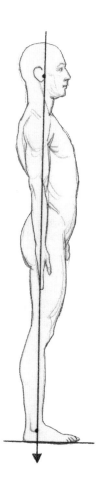

Shown left is a simplified drawing of a cross section at the approximate height of the right mid thigh. Drawing a cross section is a conceptual tool that is very useful in helping to understand the topographical relationship (with regard to position, space, volume, ratios, etc.) between the elements that make up a body segment.

Body types

The study of human physical characteristics has shown that although there are many differences between individuals, they can be grouped into three basic 'types', each with similar physical characteristics, at least in a general and generic sense. The classifications of constitutional types (developed primarily for medical diagnosis, therapy and healthcare purposes) take into consideration the degree of variation from the average characteristics of a population to which this single individual belongs and these are numerous and complex. The sketches shown on this page and the next two summarise a few characteristics of the external forms of adult male and female bodies, grouped into three types developed according to several different criteria, which are of special interest to the figurative artist for observation and study.

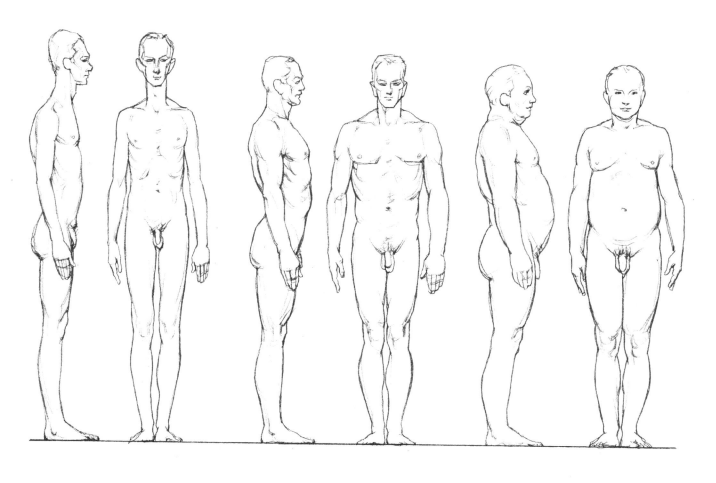

Ectomorph Mesomorph Endomorph

Ectomorph A human physical type tending towards leanness. An extreme ectomorph has a thin, often small face with a high forehead and often a receding chin, a narrow chest, rather long, thin limbs, little body fat and little muscle. He/she does not gain weight easily.

Mesomorph A human physical type tending towards muscular development. In extreme form a mesomorph has a square, large head, broad muscular chest and shoulders; he/she has minimal body fat, develops muscle easily and generally looks sturdy and muscular.

Endomorph This physical type tends towards obesity. He/she is often rotund with a narrow ribcage, prominent abdomen, pentagonal face and short limbs. Often wrists and ankles are narrow.

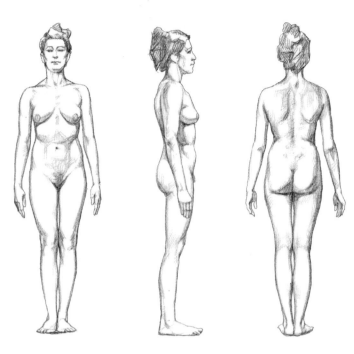

Female ectomorph

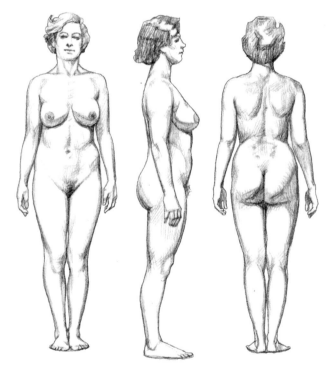

Female mesomorph

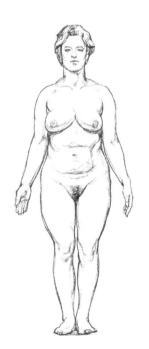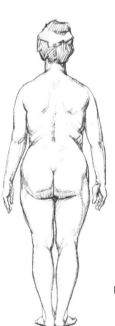

Female endomorph

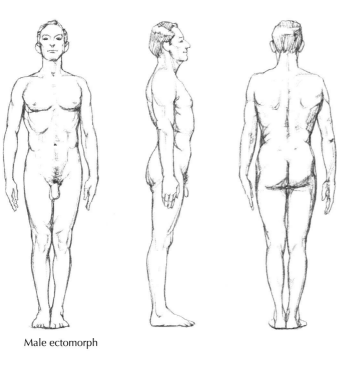

Male ectomorph

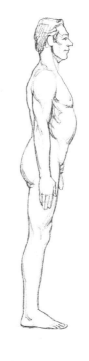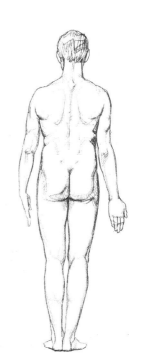

Male mesomorph

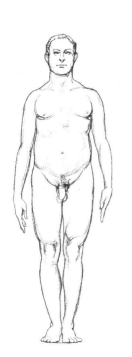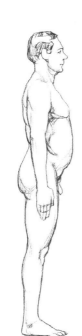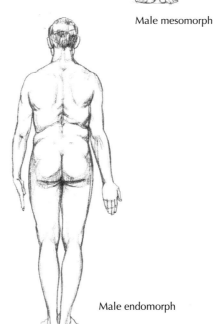

Male endomorph

3 ANATOMICAL DRAWING METHODS

The skeleton is the weight-bearing structure of the body. It determines body height and contributes to its build. It is made up of individual bones that are connected at the joints (see page 30), helping in movement when the voluntary muscles act on them, and supporting the whole body whether it is at rest or moving. The artist should recognise the portions of bones seen just below the skin as they determine or contribute to defining external forms and, when depicted correctly, can contribute a sense of rightness to the drawing. It is also easy to use the points of subcutaneous bones to deduce proportional measurements or the orientation of the principal axes of the body. (We cannot list them all here but anyone can identify them easily by carefully observing a live model or feeling them on their own body by touch and comparing the result with pictures or models of skeletons.)

The study of bone structure is useful (and interesting) when compared directly with a model, for example by drawing the model and the skeleton in the same position and from different angles.

If this is not possible, the exercise can still be done by drawing the rough skeleton on top of the photograph of a figure or working in reverse, using photographs of skeletons found in anatomical atlases.

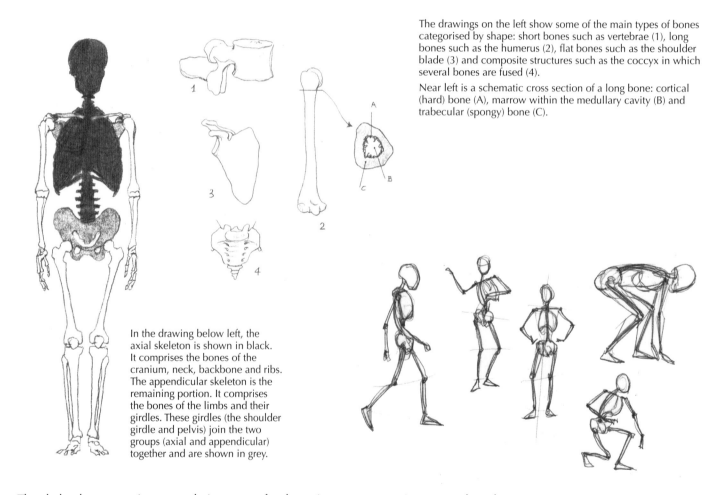

The drawings on the left show some of the main types of bones categorised by shape: short bones such as vertebrae (1), long bones such as the humerus (2), flat bones such as the shoulder blade (3) and composite structures such as the coccyx in which several bones are fused (4).

Near left is a schematic cross section of a long bone: cortical (hard) bone (A), marrow within the medullary cavity (B) and trabecular (spongy) bone (C).

In the drawing below left, the axial skeleton is shown in black. It comprises the bones of the cranium, neck, backbone and ribs. The appendicular skeleton is the remaining portion. It comprises the bones of the limbs and their girdles. These girdles (the shoulder girdle and pelvis) join the two groups (axial and appendicular) together and are shown in grey.

The skeletal structure is extremely important for the artist – even more important than the muscles – because it has a determining role in defining body form, proportions and posture. It represents the starting point, the first lines of any figure drawing, and is just as important whether you are drawing a living or imaginary model. It needs to be studied with great attention, not so much in minute detail but with regard to its general structure, summarised in masses, which visually represent the relationship between the segments, spatial orientation of the limbs, the axis of equilibrium, etc. Special care should be taken to note the essential elements of body support – the backbone and pelvis. This structure should be born in mind when making small, rapid posture sketches, like the stick drawings shown here, which are invaluable before embarking on a full figure drawing. These stick figures look like the internal armature that supports a clay sculpture; they are very expressive and useful for correctly developing the figure later on.

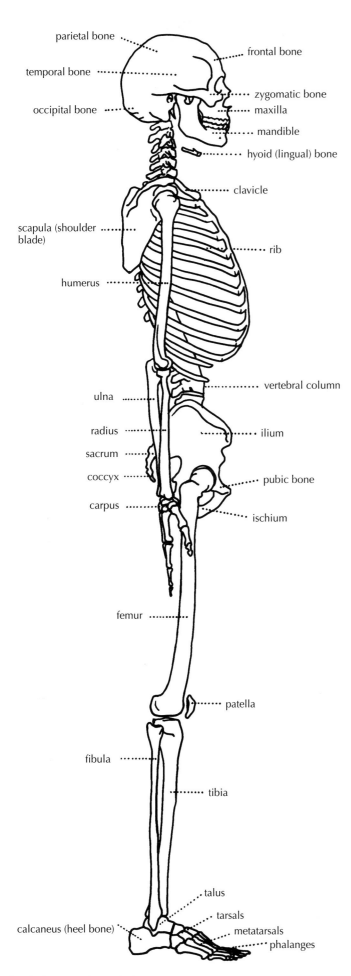
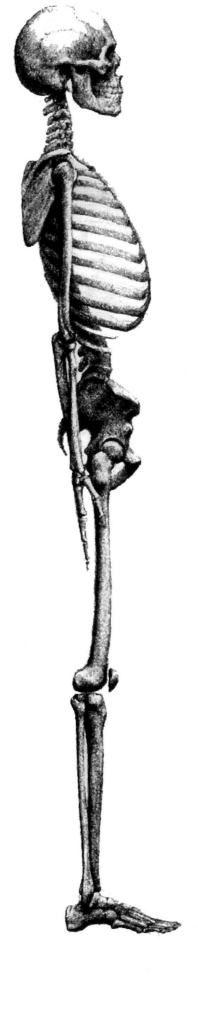

parietal bone

frontal bone

temporal bone

occipital bone

zygomatic bone

maxilla

mandible

hyoid (lingual) bone

clavicle

scapula (shoulder blade)

rib

humerus

vertebral column

ulna

radius

ilium

sacrum

coccyx

pubic bone

carpus

ischium

femur

patella

fibula

tibia

talus

tarsals

calcaneus (heel bone)

metatarsals

phalanges

Male skeleton in lateral view.

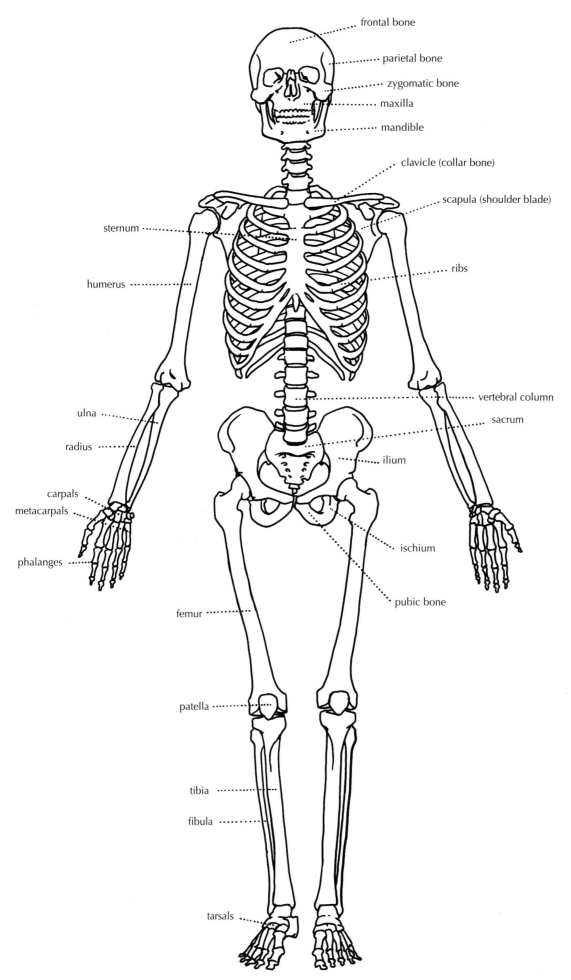

frontal bone

parietal bone

zygomatic bone

maxilla

mandible

clavicle (collar bone)

scapula (shoulder blade)

sternum

ribs

humerus

ulna

vertebral column

radius

sacrum

ilium

carpals

metacarpals

ischium

phalanges

pubic bone

femur

patella

tibia

fibula

tarsals

Male skeleton in frontal view.

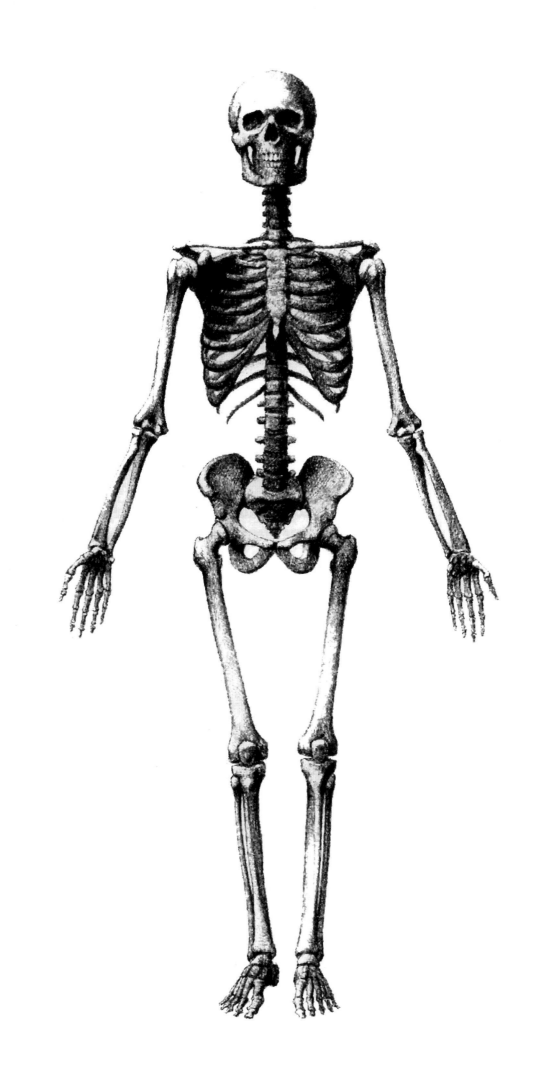

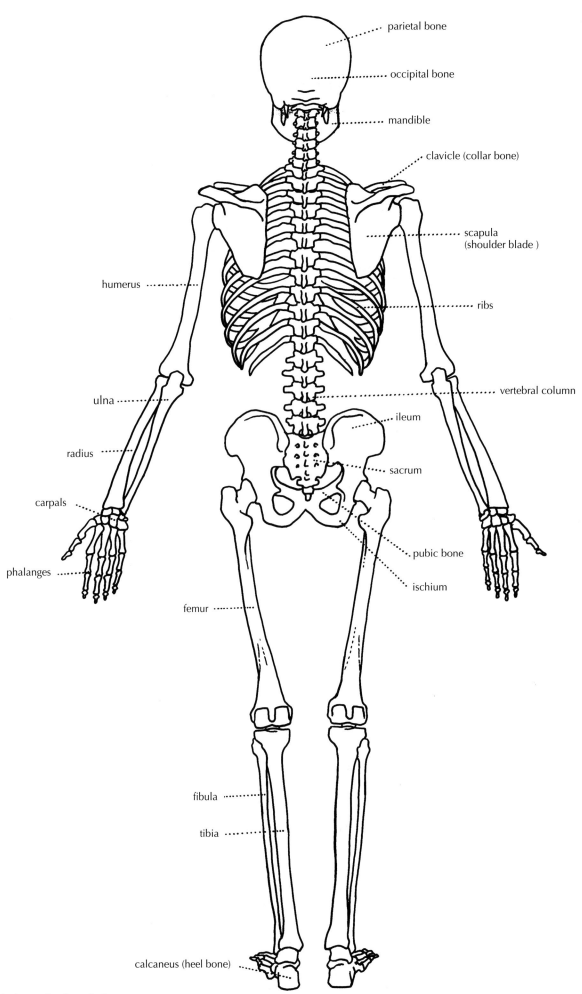

parietal bone

occipital bone

mandible

clavicle (collar bone)

scapula
(shoulder blade)

humerus

ribs

ulna

vertebral column

radius

ileum

sacrum

carpals

phalanges

pubic bone

ischium

femur

fibula

tibia

calcaneus (heel bone)

Male skeleton in dorsal view.

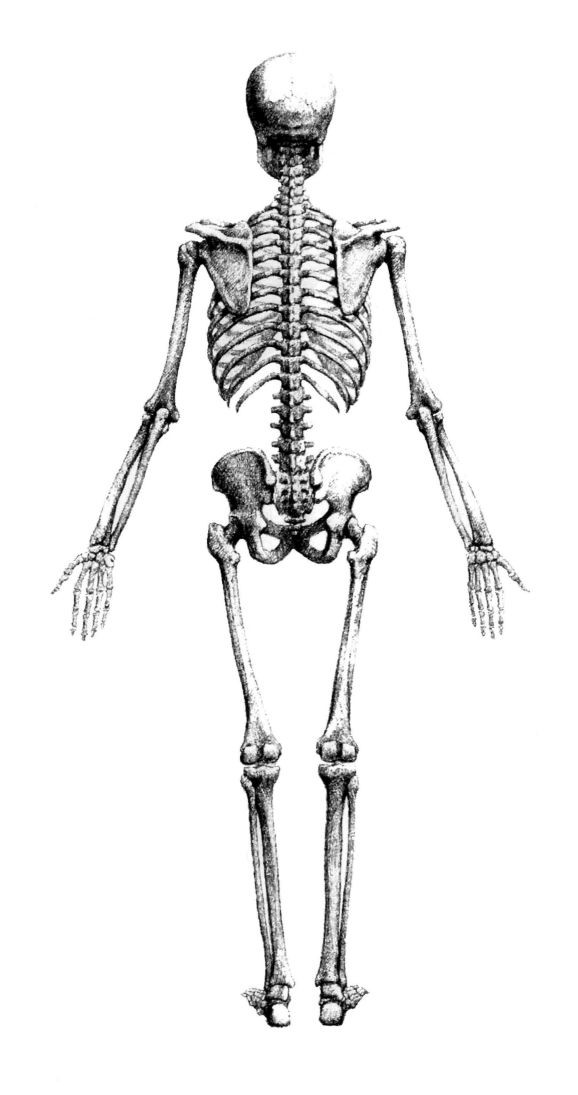

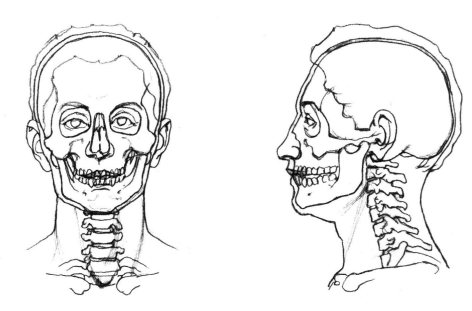

These sketches show the main bones of the head and neck with skin, cartilage, fat, muscles, hair and so on, layered on top to show how the layers sit together. The external body forms, especially with regard to the head, are determined to a large extent by the topographical relationship of the skeleton to the other layers and how well they are developed with respect to each other.

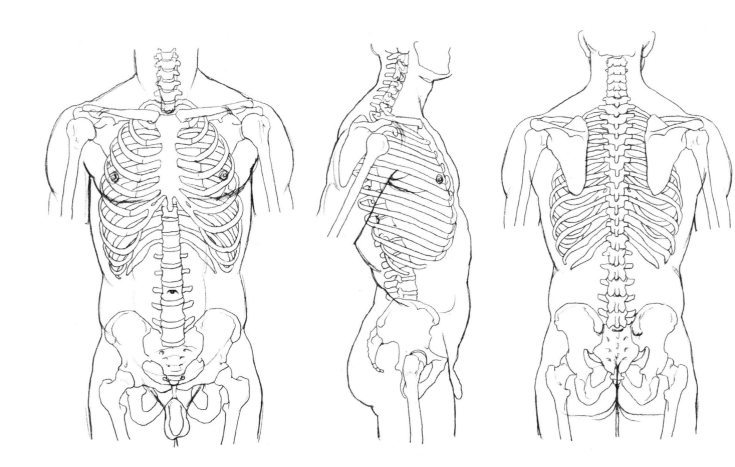

Here we see the male skeleton of the torso within the outlines of the body, seen in frontal, lateral and dorsal views. Use these drawings as a tool to extend your understanding of the forms of the body.

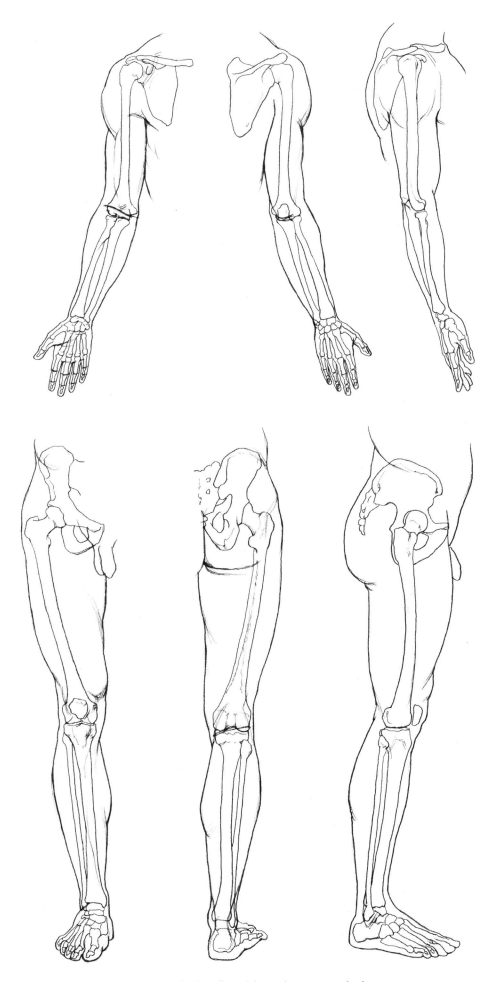

Here we see the upper and lower limbs in frontal, dorsal and lateral views. As before, the skeletal structure is shown within the context of the body.

8 THE JOINTS

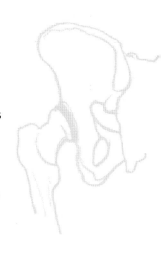

Joints are the locations at which two or more bones connect. The joints that do not allow movement or which only allow slight expansion, such as those in the skull, are called synarthrosis joints. For artistic purposes we can treat the bones that lock together as one entity.

Joints that allow a little more movement, such as those between the vertebrae are called amphiarthrosis joints while those which offer more movement are diarthrosis joints. These include the joints of the jaw, elbow, shoulder and so on. For the artist, it is very useful to acquire familiarity with at least the full range of joint movements that the bones of the limbs and trunk are capable of. Nothing jars more than a drawing of a figure in a physically impossible pose.

The drawings below show us a few rudimentary notions that are essential for understanding some joint mechanisms and should help you to recognise them in the living model. Most joints are synovial. This is where the ends of the bones are protected by cartilage and between these ends is a capsule containing synovial fluid, a lubricant. Examples of synovial joints include hinge joints (4), saddle joints (5) and ball-and-socket joints (6).

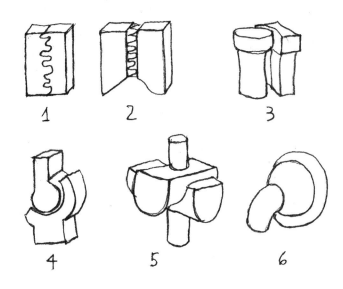

On the left are some very simplified examples of some types of joints, and below are examples of where they are used. Joints 1 and 2 are synarthrosis joints, while 3, 4, 5 and 6 are diarthrosis joints. In the synarthrosis joints, the two bones involved are joined through connective tissue inserted between the two parts, which keeps the bones tightly joined, preventing any movement or only allowing slight expansion or compression of the joint. In the cranium is a special fibrous joint that only occurs here. It is called a suture (1). A cartilaginous joint allows slightly more movement than a suture due to the cartilage connection between the bones which can, on expansion, cause a slight movement, for example in the pubic portion of the pelvis (2). A pivot joint allows for rotation, flexion, contraction and so on. The three pivot joints of the body are at the neck and at each elbow where the proximal radioulnar joint allows the rotation of the forearm at the elbow (3). A hinge joint enables the bones to move only along one axis to flex or extend. An example would be the hinge joint of the elbow (4). In a saddle joint the convex end of one bone sits in the concave portion of the other like a rider in a saddle, as shown here the temporomandibular joint (5). Another example would be the joint at the base of the thumb. Finally we have an example of the well-known ball-and-socket joint in which the ball-like end of one bone fits into the concave articulation or socket of the adjacent bone. These joints, which can move in many ways, only occur at the hip and shoulder.

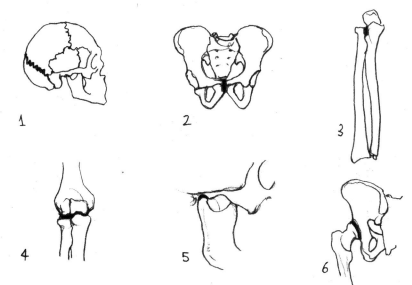

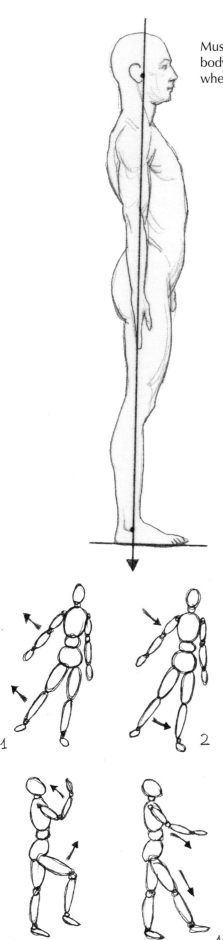

Muscles and joints are in action when the body is standing or sitting still as well as when it is in motion.

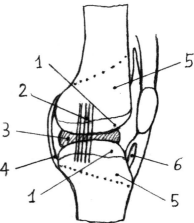

The diagram above shows the elements that make up a synovial joint, the most common type of joint in the body. This example shows the knee joint. In this type of joint the ends of the bones (rotation points) are covered with strong, smooth cartilage called articular cartilage. Further buffering is provided by the synovial fluid that is contained by the synovial membrane (the articular capsule). In the case of this joint, in order to prevent friction at the sides, there are also three bursae present. A bursa is a thin sack made of connective tissue that is filled with lubricating liquid, rather like the synovial fluid in the articular capsule. The joint is strengthened by ligaments. The illustration shows the articular cartilage (1), the position of the cruciate ligaments (2), the synovial cavity (3), the articular capsule containing the synovial fluid (4), bone, in this case the femur above the joint and the tibia below it (5) and the infrapatella bursa (6).

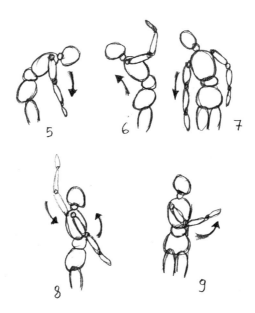

Diagrams showing basic body movements. Abduction: abductor muscles contract to move a body part outwards, away from the body (1). Adduction: adductor muscles contract to move a body part inwards (2). Flexion: bending a limb to reduce the angle of the joint (3). Extension: unbending a limb to increase the angle of the joint (4). Flexion can also refer to the forward bending of the body and\or neck (5). Extension can also refer to the backward bending of the body and/or neck (6). Lateral flexion is the bending of the spine to the side (7). Circumduction is a joint action that produces a rounded result, such as circling the arms (8). Rotation is turning around the central axis (9).

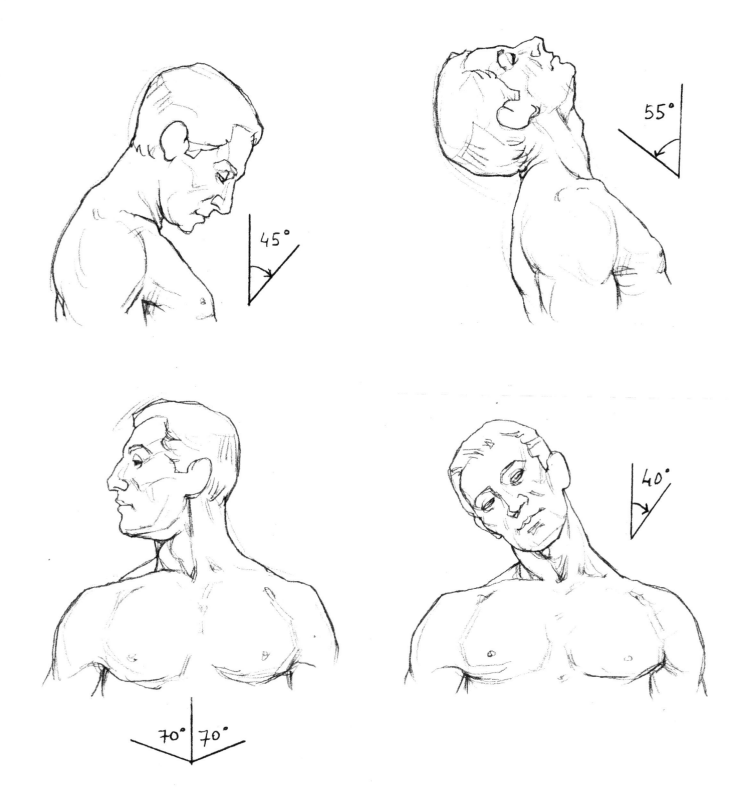

This series of diagrams shows possible neck movements. The extent of movement is dependent on the action of the muscles and the possible movements of the vertebrae, which is limited by their shape, the ligaments, vertebral discs and so on. The sketches show the principal movements: flexion, extension, rotation and lateral flexion, and shows the degree of bending, with respect to the median line, which can, on average, be achieved. This value is quite difficult to quantify as it depends on the sum of many small movements that take place thanks to a series of interactive joints.

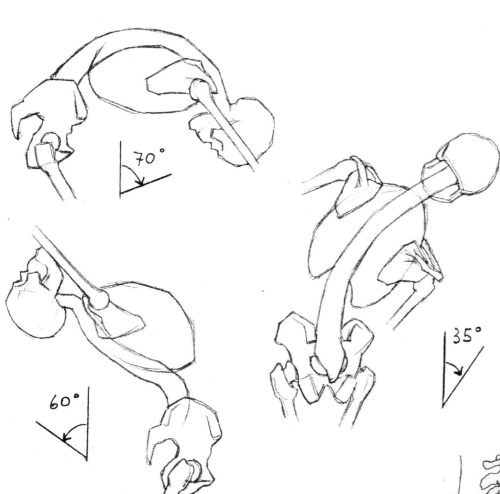

The same restrictions that apply to the neck also apply to the torso (see illustrations left). The vertebral column is strong and compact, but also fairly flexible, especially in the lumbar and cervical regions, and allows for ample forward flexion. On the other hand, flexion and sideways extension are more limited, partly because of inter-vertebral ligaments, the protrusion of the vertebral processes and the constraints of the ribcage. Regular exercises to increase mobility, such as yoga exercises, will increase the potential range of movements.

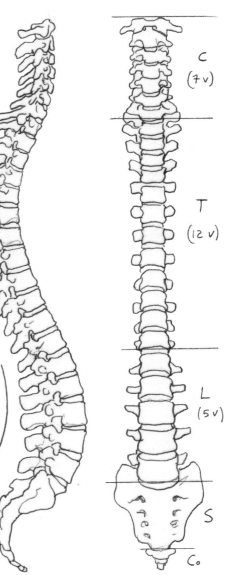

The illustrations shown right are of the vertebral column, seen in lateral and frontal views. The vertebral column is the support structure (strong but flexible) of the whole torso and fits on to the pelvis. It is made up of 33–34 vertebrae arranged in a series, one on top of the other, interspaced with vertebral discs. Each vertebra is composed of a nearly cylindrical body with bony spines leading outwards. Their shape and size allow us to classify the vertebrae into five regions, which together make up the vertebral column: the seven cervical vertebrae at the top, in the neck; the 12 thoracic (or dorsal) vertebrae of the upper back, which are not very mobile as they are joined to the ribs; the five lumbar vertebrae in the waist area; the five sacral vertebrae, and finally the three to five vertebrae of the coccyx. While the vertebrae in the top three sections are jointed to allow flexibility, the vertebrae of lowest two are almost completely fused together. In the anatomically positioned skeleton, the frontal (or dorsal) view normally shows a straight progression of vertebrae, while the lateral view shows a series of alternating curves, two convex (A) and two concave (B).

9 THE MUSCLES

It is the muscle system that is responsible for the movement of the body. There are three groups of muscles: the skeletal muscles, which are attached to the skeleton and which are controlled consciously by the mind; the visceral muscles, which are found in the organs, such as the stomach and blood vessels, and the cardiac muscle, which is in the heart. For our purposes, we are only interested in the skeletal muscles.

The skeletal muscle system is made up of a combination of voluntary striated muscles and connected tissues (fascia, sheaths, etc.). There are hundreds of skeletal muscles. Their exact number depends upon the criteria used for their classification, but it is generally agreed that there are five hundred or more, contributing significantly to the body's weight. Their volume in each individual depends upon various factors: sex, age, constitutional type, state of health, physical fitness, etc.

The basic action of any skeletal muscle is contraction – when you think about moving your arm, your brain sends a signal down a nerve telling the muscle(s) to contract by the amount required for the action. Each muscle comprises a bundle of cells called fibres, which are basically long cylinders. The muscles are held on to the bones with the help of tendons, which are strong cords of tissue. Skeletal muscles are inserted onto bones through at least two tendon heads, which are positioned at its extremities: the origin tendon and the insertion tendon, conventionally named this way, with the origin fixed to the more stable bone and the insertion fixed to the more mobile bone (the one that moves as a result of the muscular contraction). The diagrams on this page summarise some of the main characteristics of skeletal muscles.

For the artist's purposes, there are three main aspects to consider with regard to a muscle: its appearance (form, dimension, volume); its position (where it is on the skeleton, its relationship to adjacent muscles, whether deep or superficial); and its action (function, axis of traction, resulting changes in shape, etc.). In real life, on a model, we can guess the appearance and volume of the muscle below the skin. These vary depending upon whether they are examined in a state of relaxation (when all we see evidence of is simply the 'tone') or in a state of contraction. This latter state can be illustrated in two ways: isotonic contraction, in which the contractile part shortens and increases in volume, as when bending the elbow to contract the biceps muscle, and isometric tension, in which the fleshy part does not shorten, but increases its tone, as when carrying a heavy bag or holding out a tennis racket.

Because muscles only work by contracting, they work in pairs. When we move, say, an arm, one muscle, the agonist muscle (prime mover), contracts. To return to the start position, another muscle, the antagonist muscle, contracts the other way. In a biceps curl, for example, the biceps pulls up and the triceps pulls back. Fixator muscles stabilise the body in opposition to gravity or the action of the agonist muscles. Yet more muscles, the synergist muscles, stabilise movements to keep them limited to a safe range of motion. Thus, we observe that even a simple movement of the body calls for the coordination of several muscles.

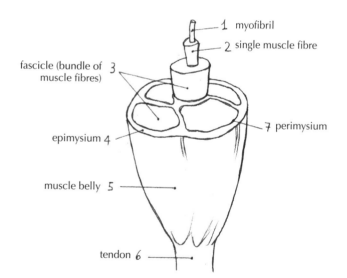

1 myofibril
2 single muscle fibre
fascicle (bundle of muscle fibres) 3
7 perimysium
epimysium 4
muscle belly 5
tendon 6

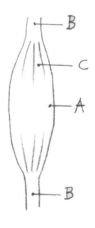

The diagrams left show the basic structure of a skeletal muscle: muscle belly (A), tendon (B) and epimysium or deep fascia (C). Note that the tendon fixed to the more stable bone is conventionally called the origin and the one fixed to the more mobile one is called the insertion tendon. Deep fascia is dense, fibrous connective tissue that adds stability and strength and provides communication.

Shown right is a cross section of the muscles of a limb (arm). It is important that the artist practices assessing the spatial relationship and the relative proportions of the muscles and other skeletal formations because this helps greatly in efficient volumetric portrayal. Practically all anatomical atlases dedicate a large number of useful images to this concept (obtained from actual cadaver sections or, more frequently, produced through x-rays, MRIs, CAT scans, etc.)

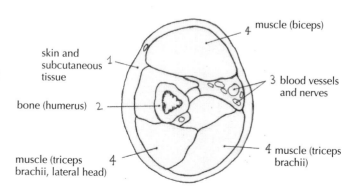

skin and subcutaneous tissue 1
4 muscle (biceps)
3 blood vessels and nerves
bone (humerus) 2
muscle (triceps brachii, lateral head) 4
4 muscle (triceps brachii)

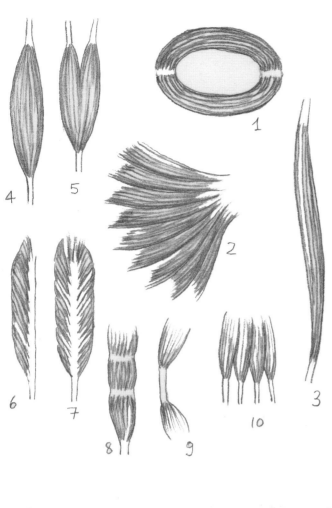

Some types and shapes of skeletal muscles:
1. circular (obilcuaris oculi of the eye; obicularis oris of the lips).
2. convergent (pectoralis major).
3. long, parallel (sartorius).
4. fusiform (tensor fasciae latae).
5. parallel fusiform (biceps brachii or biceps femoris).
6. unipennate (palmar interosseous, etc.).
7. bipennate (rectus femoris, extensor digitorum etc.).
8. wide, parallel (abs and lower abdominals, etc.).
9. digastric.
10. multi-headed (flexor digitorum profundus, etc.).

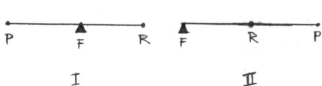

The principle of skeletal movement is the same as with levers, which is the simplest kind of mechanism.
E = effort (muscle); F = fulcrum (joint); L = load (weight or passive weight of the limb).
I – class 1 lever: the fulcrum is between the effort and the load (scissors).
II – class 2 lever: the load is between the fulcrum and the effort (wheelbarrow).
III – class 3 lever: the effort is between the fulcrum and the load (tongs).

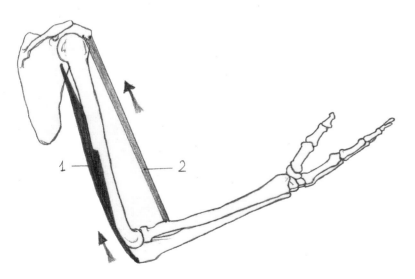

Illustration showing dynamic muscle action (flexion/extension). During flexion, the biceps are the agonist and the triceps are the antagonist and stabiliser. The opposite happens during extension.
1. triceps
2. biceps brachii

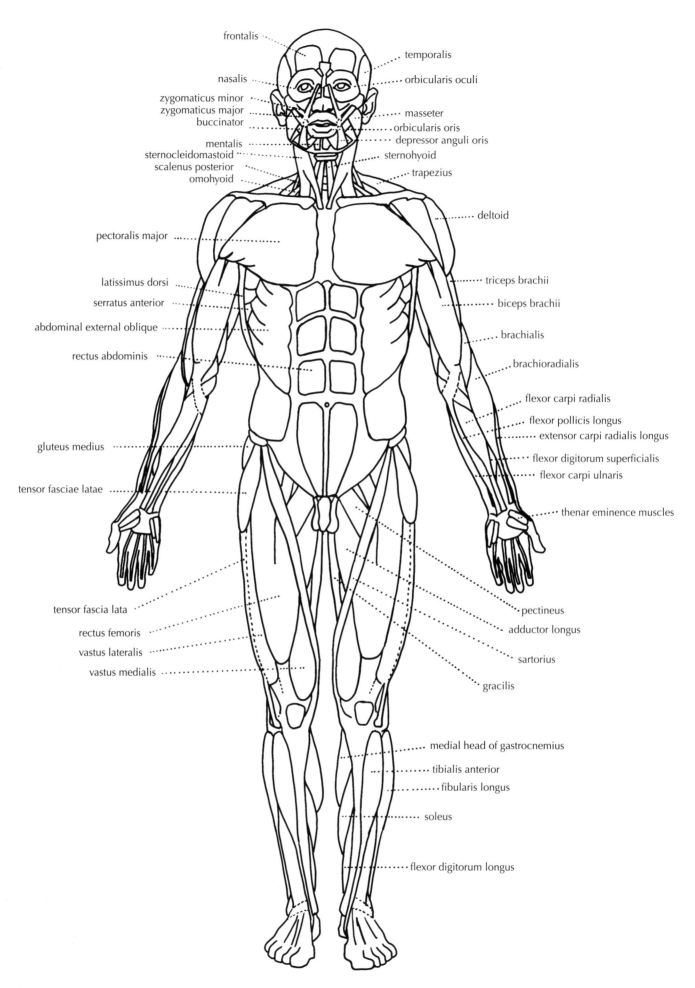

Illustration of human superficial muscles in frontal view.

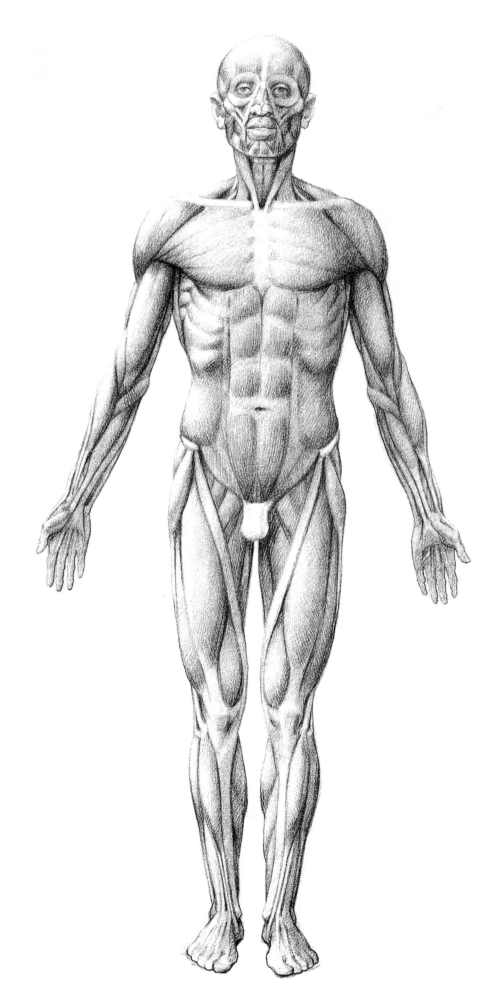

Tonal drawing of the superficial muscles in frontal view.

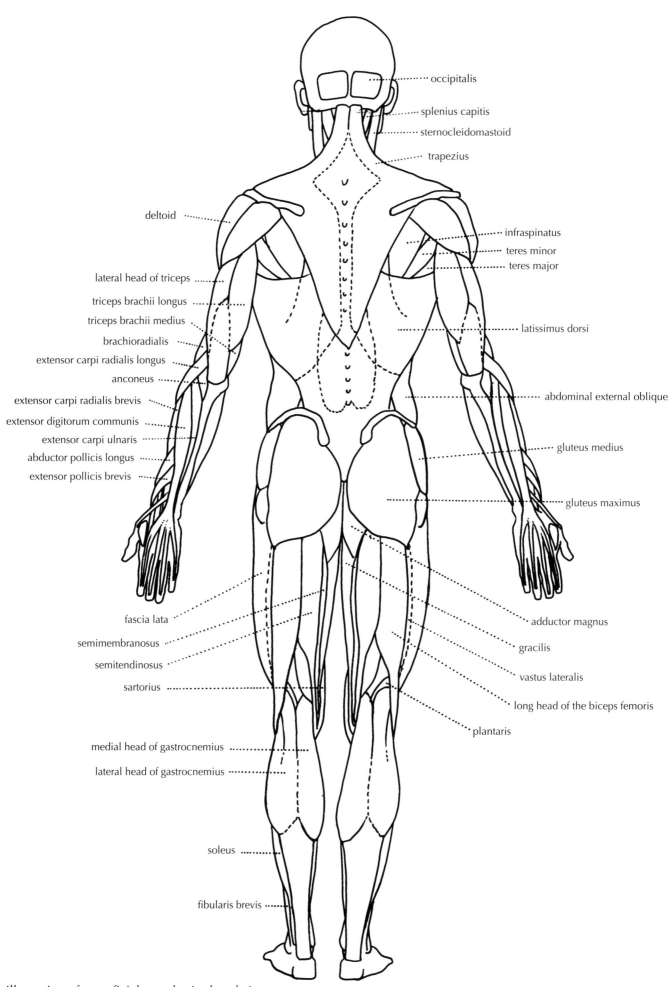

occipitalis

splenius capitis

sternocleidomastoid

trapezius

deltoid

infraspinatus

teres minor

teres major

lateral head of triceps

triceps brachii longus

triceps brachii medius

brachioradialis

extensor carpi radialis longus

anconeus

extensor carpi radialis brevis

extensor digitorum communis

extensor carpi ulnaris

abductor pollicis longus

extensor pollicis brevis

latissimus dorsi

abdominal external oblique

gluteus medius

gluteus maximus

fascia lata

semimembranosus

semitendinosus

sartorius

adductor magnus

gracilis

vastus lateralis

long head of the biceps femoris

plantaris

medial head of gastrocnemius

lateral head of gastrocnemius

soleus

fibularis brevis

Illustration of superficial muscles in dorsal view.

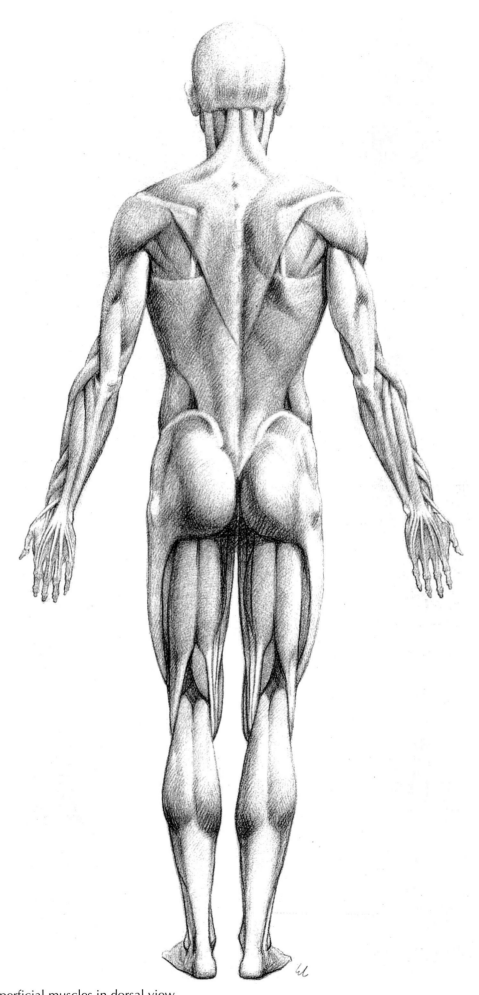

Tonal drawing of the superficial muscles in dorsal view.

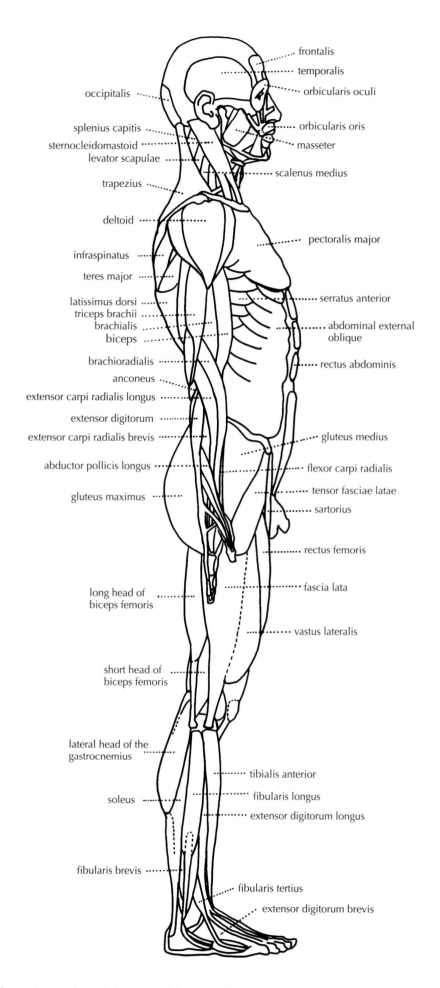
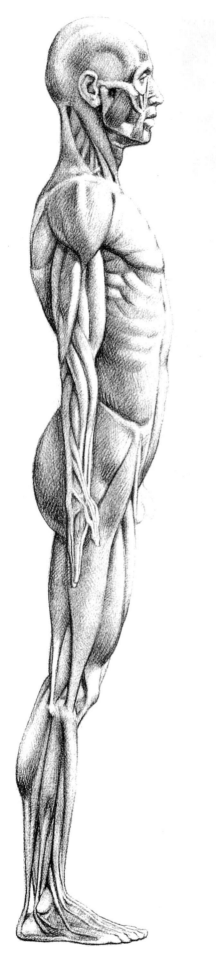

frontalis

temporalis

orbicularis oculi

occipitalis

orbicularis oris

splenius capitis

masseter

sternocleidomastoid

levator scapulae

scalenus medius

trapezius

deltoid

pectoralis major

infraspinatus

teres major

latissimus dorsi

serratus anterior

triceps brachii

brachialis

abdominal external oblique

biceps

brachioradialis

rectus abdominis

anconeus

extensor carpi radialis longus

extensor digitorum

gluteus medius

extensor carpi radialis brevis

abductor pollicis longus

flexor carpi radialis

gluteus maximus

tensor fasciae latae

sartorius

rectus femoris

long head of biceps femoris

fascia lata

vastus lateralis

short head of biceps femoris

lateral head of the gastrocnemius

tibialis anterior

soleus

fibularis longus

extensor digitorum longus

fibularis brevis

fibularis tertius

extensor digitorum brevis

Illustration and tonal drawing of the superficial muscles in right side view.

40

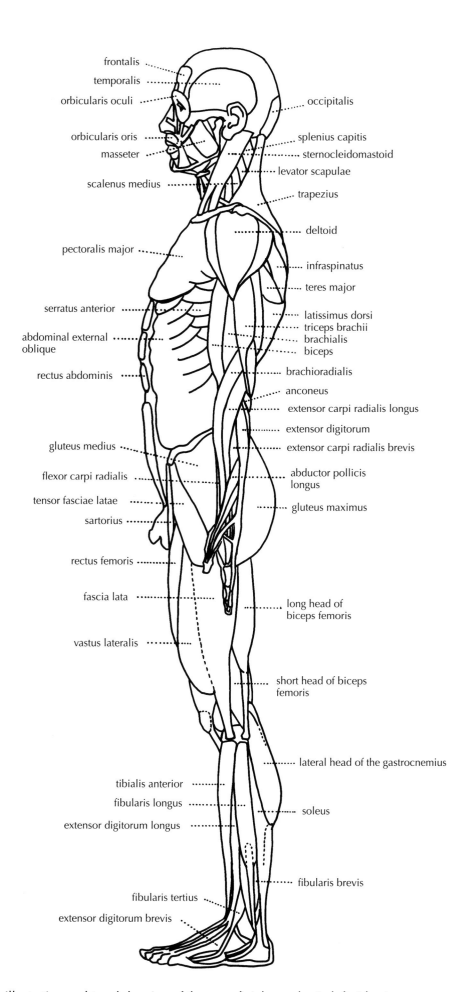

frontalis
temporalis
orbicularis oculi
orbicularis oris
masseter
scalenus medius
pectoralis major
serratus anterior
abdominal external oblique
rectus abdominis
gluteus medius
flexor carpi radialis
tensor fasciae latae
sartorius
rectus femoris
fascia lata
vastus lateralis
tibialis anterior
fibularis longus
extensor digitorum longus
fibularis tertius
extensor digitorum brevis

occipitalis
splenius capitis
sternocleidomastoid
levator scapulae
trapezius
deltoid
infraspinatus
teres major
latissimus dorsi
triceps brachii
brachialis
biceps
brachioradialis
anconeus
extensor carpi radialis longus
extensor digitorum
extensor carpi radialis brevis
abductor pollicis longus
gluteus maximus
long head of biceps femoris
short head of biceps femoris
lateral head of the gastrocnemius
soleus
fibularis brevis

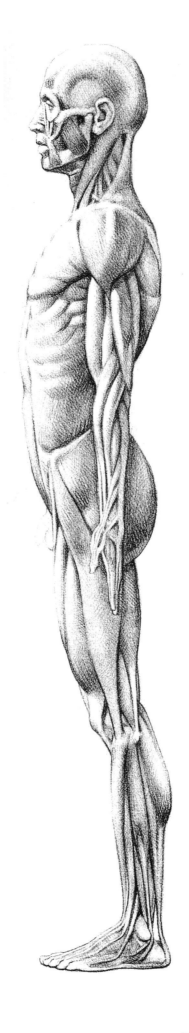

Illustration and tonal drawing of the superficial muscles in left side view.

10 SUMMARY OF ANATOMY

I think it is useful to present a series of illustrations to summarise what I have explained so far. These can be easily consulted while drawing. They show the outer appearance of the skeletal and muscular systems with regard to the different body sections: the head, torso and limbs. The simplified drawings all refer to the anatomical position (see page 6) and are arranged in the three classical projections (frontal, lateral and dorsal). This is all you need to understand body volume, even when considering a figure in other positions and from different perspectives.

The anatomical structure of the head

Line drawing of a male skull/cranium (adult, Caucasian), in the frontal and lateral views:

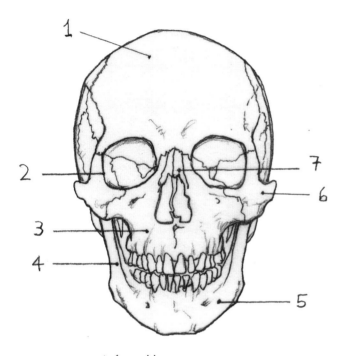 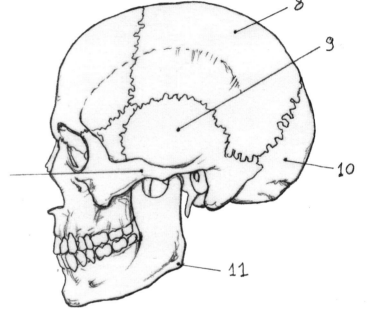

1 frontal bone
2 orbital rim
3 maxilla
4 ramus of the mandible
5 mandible
6 zygomatic bone

7 nasal bone
8 parietal
9 temporalis
10 occipitalis
11 gonial angle of mandible
12 zygomatic arch

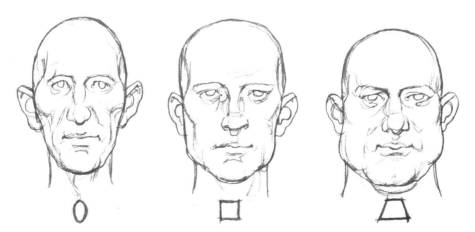

The shape of the skull contributes decisively to the shape of the head because the soft tissues (muscles, fat, skin, etc.) are not very thick in this area and therefore follow the structure of the skull quite faithfully.

 In normal observation we can associate simple geometric shapes with the outline of a head, which could, for instance, be oval, square or trapezoid.

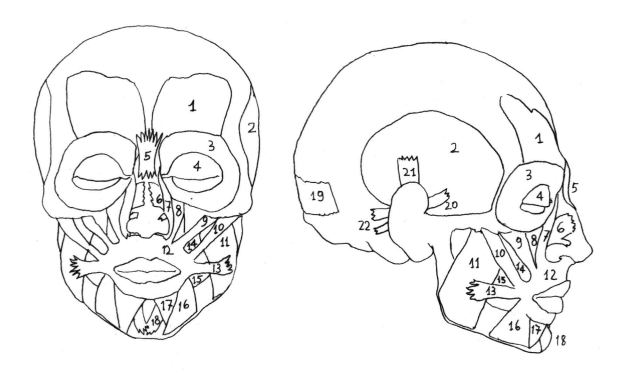

Diagram of facial muscles in frontal and lateral view, showing the muscles in diagrammatic form (above) and as tonal studies (below):
1 occipitofrontalis (frontal belly); 2 temporalis; 3 orbicularis muscle of the eye (orbital part); 4 orbicularis muscle of the eye (eyelid part); 5 procerus; 6 nasalis; 7 levator labii superioris; 8 levator anguli oris; 9 zygomaticus minor; 10 zygomaticus major; 11 masseter; 12 orbicularis oris; 13 risorius; 14 levator anguli oris (caninus); 15 buccinator; 16 depressor anguli oris (triangolaris); 17 depressor labii inferioris; 18 mentalis; 19 occipitofrontalis (occipital belly); 20 auricularis anterior; 21 auricularis superior; 22 auricularis posterior.

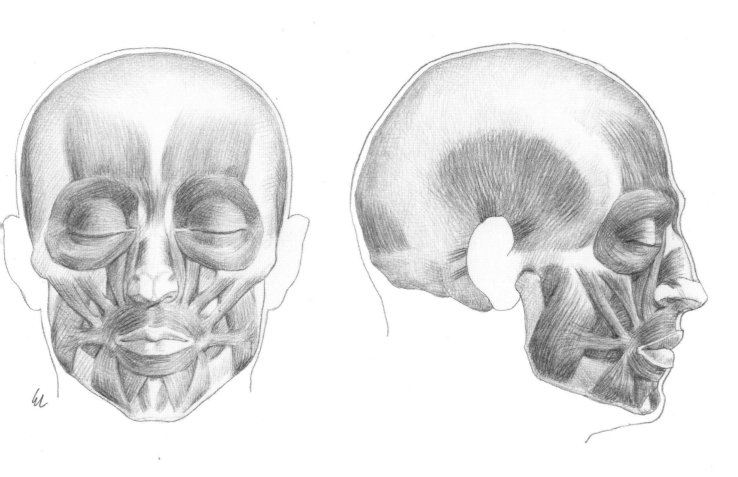

The anatomical structure of the torso

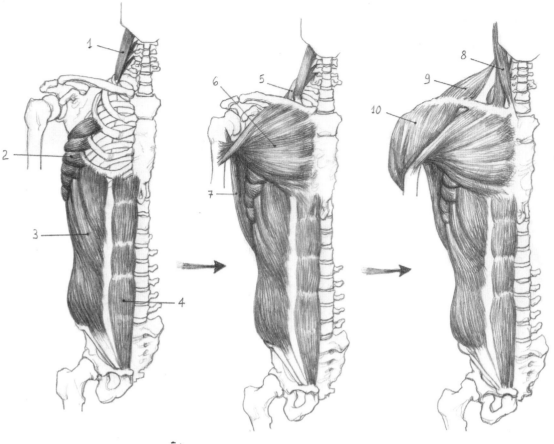

Tonal diagrams showing relevant muscles of the torso in frontal view, from deep to superficial layers.
1 scalenus medius
2 serratus anterior
3 abdominal external oblique
4 rectus abdominis
5 levator scapulae
6 pectoralis major
7 latissimus dorsi
8 sternocleidomastoid
9 trapezius
10 deltoid

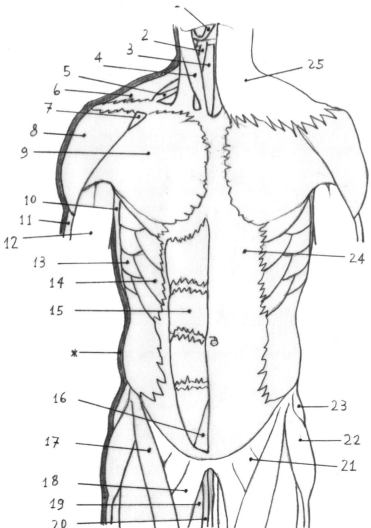

Diagram showing muscles and notable points of the torso in frontal view.
* The thick, dark outline shows the thickness of skin and subcutaneous layers.
1 digastricus
2 sternohyoid
3 sternothyroid
4 sternocleidomastoid
5 omohyoid
6 trapezius
7 clavipectoral triangle
8 deltoid
9 pectoralis major
10 latissimus dorsi
11 triceps brachii
12 biceps
13 serratus anterior
14 abdominal external oblique
15 rectus abdominis
16 pyramidalis
17 sartorius
18 pectineus
19 adductor longus
20 gracilis
21 iliacus
22 tensor fasciae latae
23 gluteus medius
24 rectus sheath
25 platysma

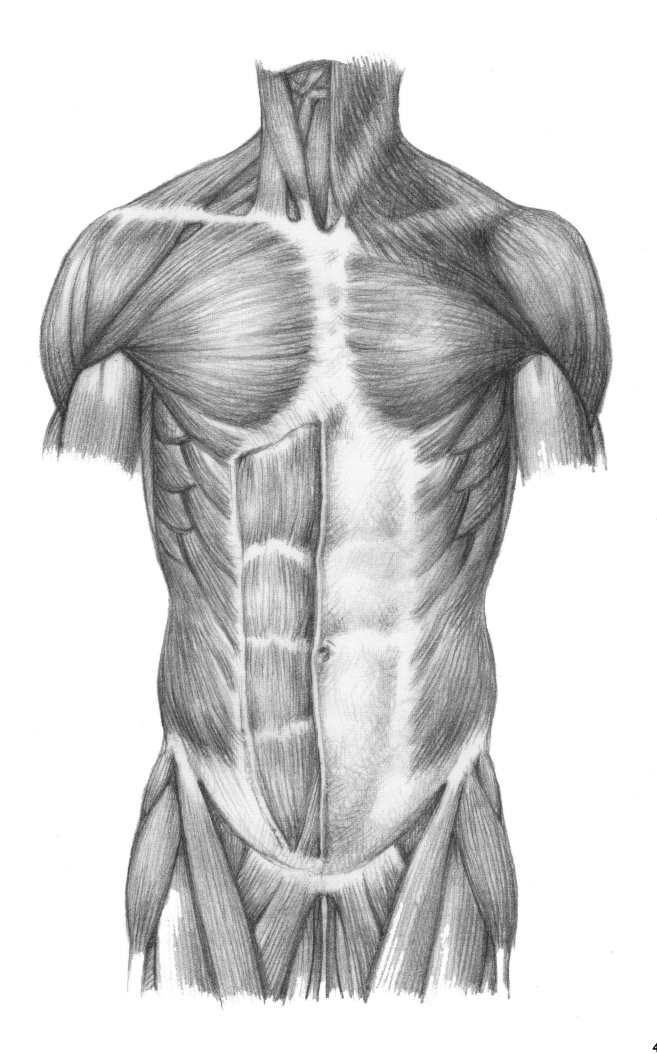

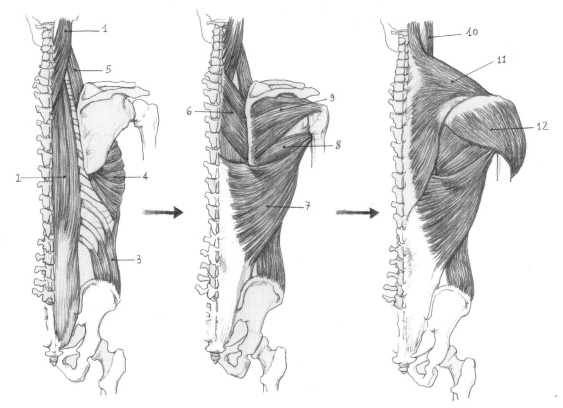

Tonal diagrams showing relevant back muscles from deep to superficial layers.
1 splenius capitis
2 erector spinae (ileocostalis, longissimus, spinalis)
3 abdominal external oblique
4 serratus anterior
5 levator scapulae
6 rhomboid major and minor
7 latissimus dorsi
8 teres major
9 infraspinatus
10 sternocleidomastoid
11 trapezius
12 deltoid

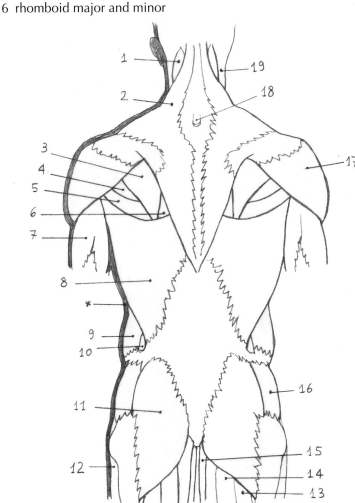

Diagram showing relevant muscles and notable points of the torso in dorsal view.
* The thick, dark outline shows the thickness of skin and subcutaneous layers.
1 splenius capitis
2 trapezius
3 infraspinatus
4 teres minor
5 teres major
6 rhomboid
7 triceps brachii
8 latissimus dorsi
9 abdominal exterior oblique
10 lumbar triangle
11 gluteus maximus
12 tensor fasciae latae
13 biceps femoris
14 semitendinosus
15 gracilis
16 gluteus medius
17 deltoid
18 seventh cervical vertebra
19 sternocleidomastoid

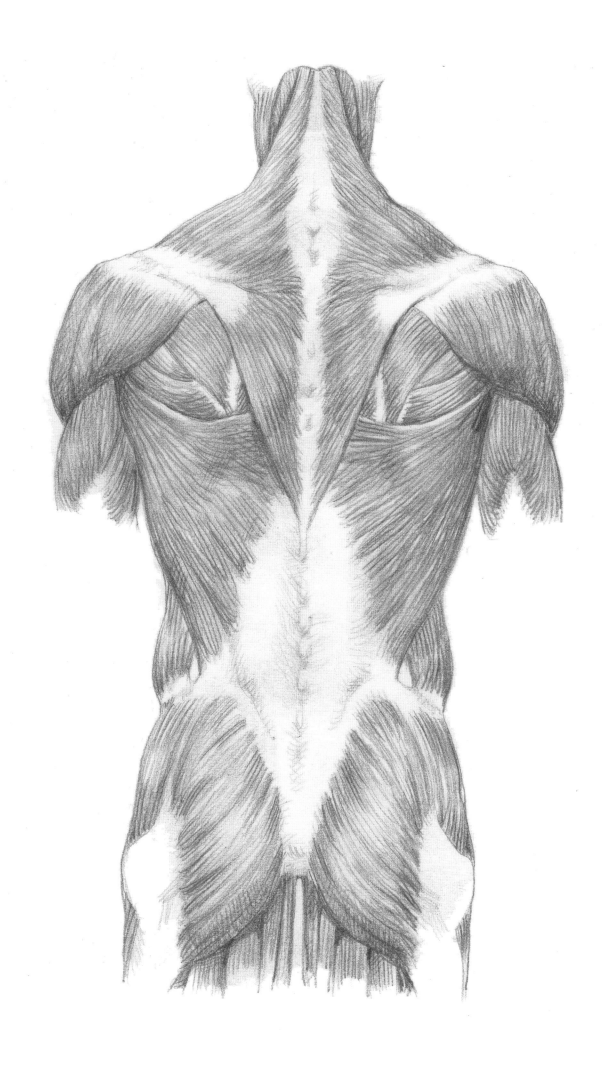

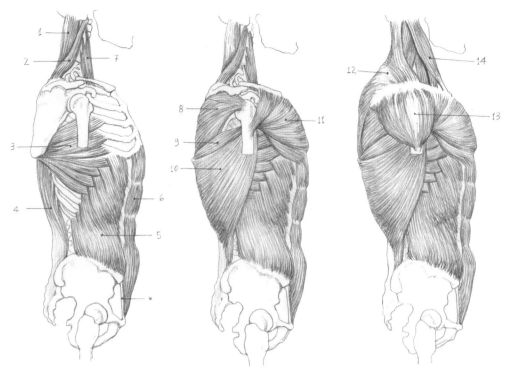

Tonal diagrams of relevant muscles of the torso in lateral view, from deep to superficial layers.
The inguinal ligament is marked with *. It supports the external abdominal oblique muscle as
well as the soft tissue in the groin.

1 splenius capitis
2 levator scapulae
3 serratus anterior
4 sacrospinalis
5 abdominal external oblique
6 rectus abdominis
7 scalenus medius

8 infraspinatus
9 teres major
10 latissimus dorsi
11 pectoralis major
12 trapezius
13 deltoid
14 sternocleidomastoid

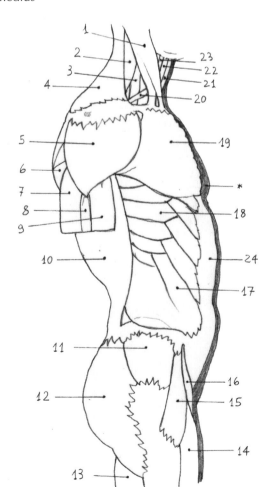

Diagram showing relevant muscles of the torso in
lateral view:
* The thick, dark outline shows the thickness of skin
and subcutaneous layers.
 1 sternocleidomastoid
 2 splenius capitis
 3 scalene muscle
 4 trapezius
 5 deltoid
 6 teres major
 7 triceps brachii
 8 brachialis
 9 biceps
 10 latissimus dorsi
 11 gluteus medius
 12 gluteus maximus
 13 biceps femoris
 14 rectus femoris (one of the quadriceps)
 15 tensor fasciae latae
 16 sartorius
 17 abdominal exterior oblique
 18 serratus anterior
 19 pectoralis major
 20 and 22 omohyoid
 21 sternohyoid
 23 thyrohyoid
 24 rectus sheath

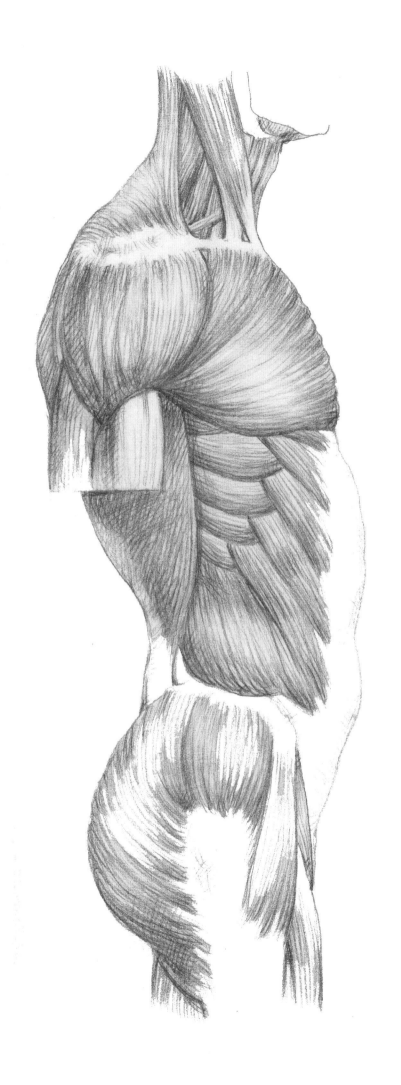

The anatomical structure of the upper limb

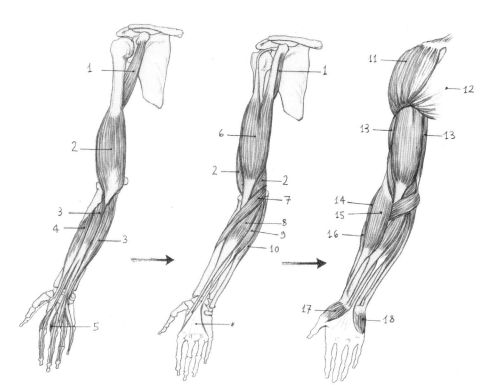

Tonal diagrams of relevant upper arm muscles in frontal view, from deep to superficial layers.

1 coracobrachialis
2 brachialis
3 flexor digitorum profundus
4 flexor pollicis longus
5 lumbricals (one on each finger)
6 biceps brachii
7 pronator teres
8 flexor carpi radialis
9 palmaris longus
10 flexor carpi ulnaris
11 deltoid
12 pectoralis major
13 triceps brachii
14 extensor carpi radialis longus
15 brachioradialis
16 extensor carpi radialis brevis
17 thenar eminence
18 hypothenar eminence
* palmar aponeurosis (tendon complex of the palm)

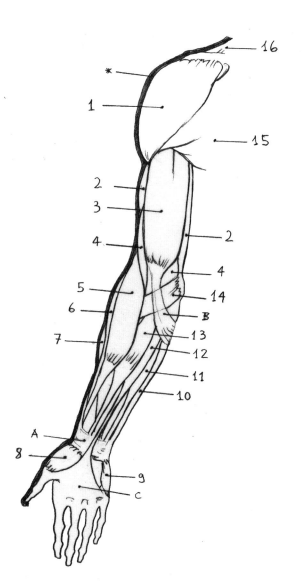

Diagram of the right upper arm muscles in frontal view.
* The thick, dark outline shows the thickness of skin and subcutaneous layers.

1 deltoid
2 triceps brachii
3 biceps brachii
4 brachialis
5 brachioradialis
6 extensor carpi radialis longus
7 extensor carpi radialis brevis
8 thenar eminence
9 palmaris brevis and hypothenar muscles
10 flexor carpi ulnaris
11 flexor digitorum superficialis
12 palmaris longus
13 flexor carpi radialis
14 pronator teres
15 pectoralis major
16 trapezius
A. flexor retinaculum (transverse carpal ligament)
B. bicipital aponeurosis (tendons)
C. palmar aponeurosis (tendons)

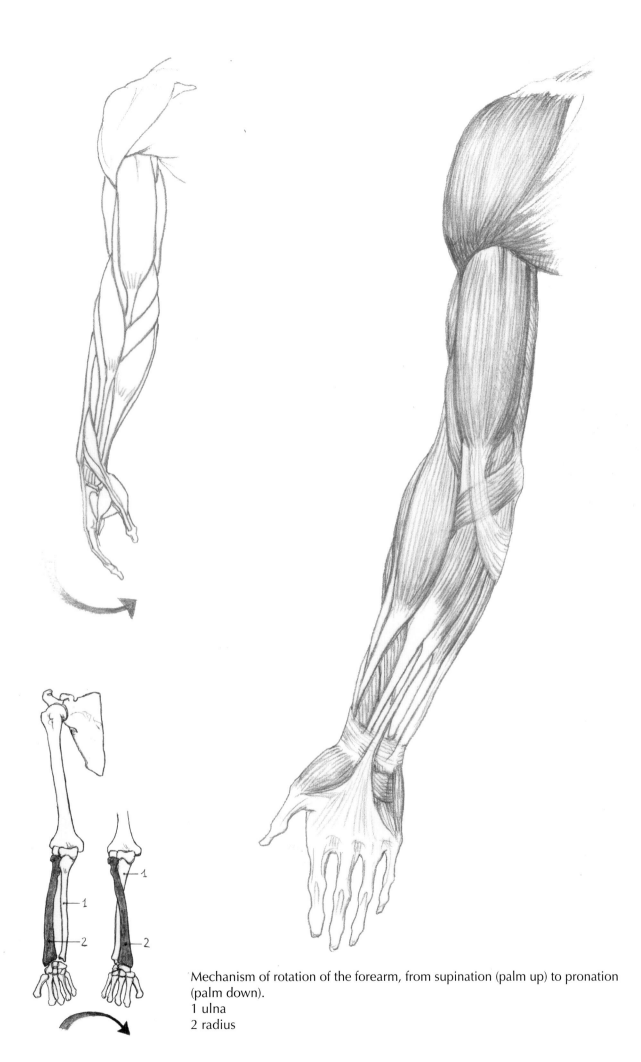

Mechanism of rotation of the forearm, from supination (palm up) to pronation (palm down).
1 ulna
2 radius

Tonal diagrams of relevant upper
limb muscles in dorsal view
from deep to superficial layers.

1 triceps brachii: long head
 (A), medial head (B) and
 lateral head (C)
2 flexor digitorum profundus
3 anconeus
4 teres major
5 extensor digiti minimi
6 extensor carpi ulnaris
7 extensor pollicis brevis
8 abductor pollicis longus
9 extensor digitorum
 communis
10 extensor carpi radialis brevis
11 extensor carpi radialis
 longus
12 brachioradialis
13 teres minor
14 infraspinatus
15 supraspinatus
16 flexor carpi ulnaris (covers
 the flexor digitorum
 profundus)
17 hypothenar eminence
18 first dorsal interosseous
19 deltoid

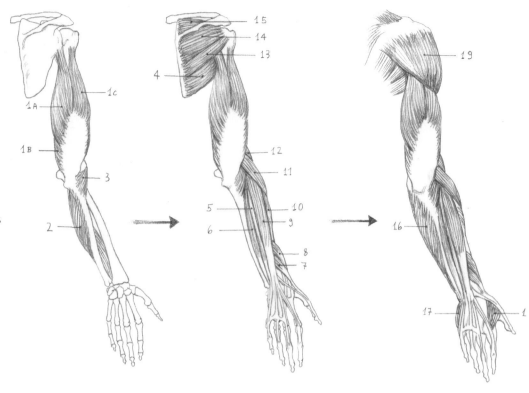

Diagram of superficial upper limb muscles in dorsal view:
* The thick, dark outline shows the thickness of skin and
subcutaneous layers.

1 trapezius
2 infraspinatus
3 teres major
4 triceps brachii
5 anconeus
6 flexor carpi ulnaris
7 extensor carpi ulnaris
8 hypothenar eminence muscles
9 first dorsal interosseous
10 extensor hallucis brevis
11 abductor pollicis longus
12 extensor digiti minimi
13 extensor carpi radialis brevis
14 extensor digitorum communis
15 extensor carpi radialis longus
16 brachioradialis
17 deltoid
A. flexor retinaculum (transverse carpal ligament)

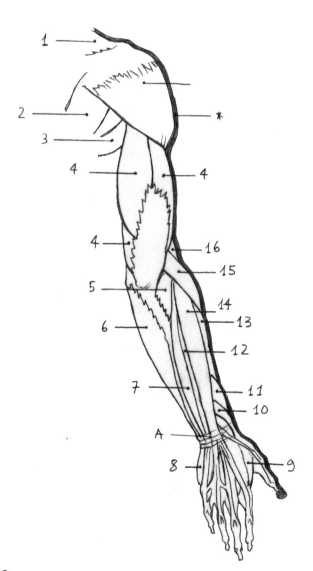

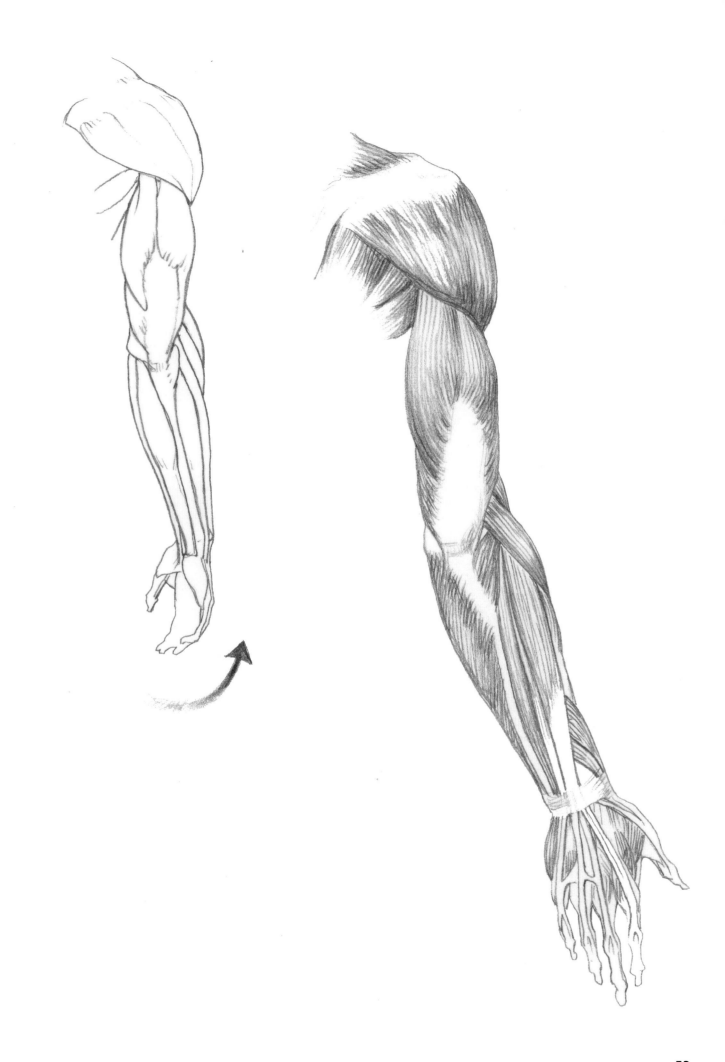

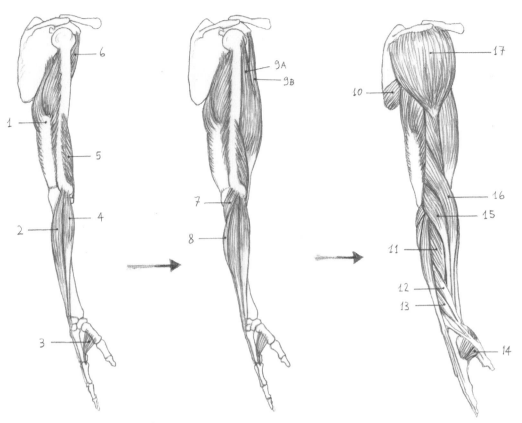

Tonal diagrams of relevant upper limb muscles in lateral view from deep to superficial layers.

1 triceps brachii
2 extensor digitorum communis
3 first dorsal interosseous
4 extensor carpi radialis brevis
5 brachialis
6 coracobrachialis
7 anconeus
8 extensor carpi ulnaris
9 biceps brachii: long head (A) and short head (B)
10 teres major
11 extensor carpi radialis brevis
12 abductor pollicis longus
13 extensor hallucis brevis
14 adductor pollicis
15 extensor carpi radialis longus
16 brachioradialis
17 deltoid

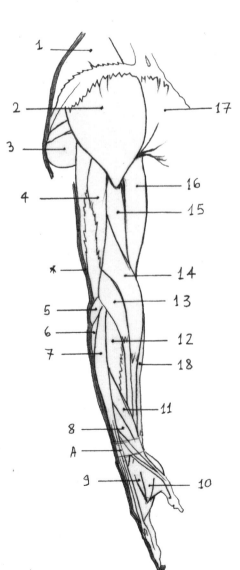

Diagram of right upper limb muscles in lateral view:
* The thick, dark outline shows the thickness of skin and subcutaneous layers.

1 trapezius
2 deltoid
3 teres major
4 triceps brachii
5 anconeus
6 extensor digiti minimi
7 extensor digitorum communis
8 extensor hallucis brevis
9 first dorsal interosseous
10 adductor pollicis
11 abductor pollicis
12 extensor carpi radialis brevis
13 extensor carpi radialis longus
14 brachioradialis
15 brachialis
16 biceps
17 pectoralis major
18 flexor carpi radialis
A. flexor retinaculum (transverse carpal ligament)

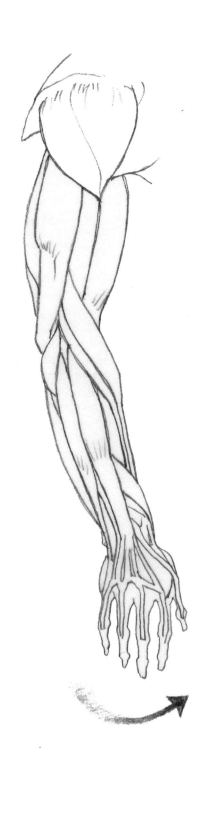

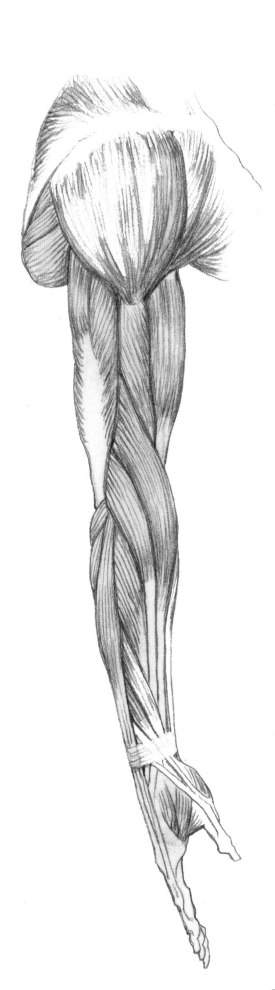

The anatomical structure of the lower limb

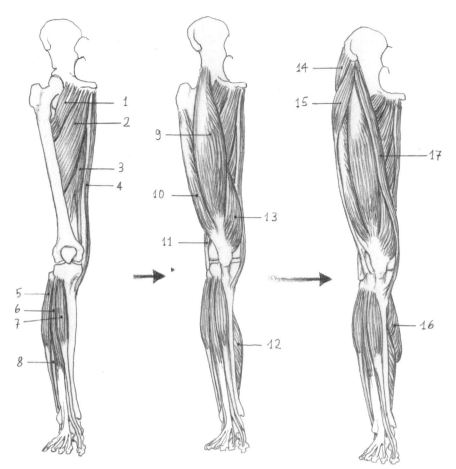

Tonal diagrams of relevant lower limb muscles in frontal view, from deep to superficial layers.
1 pectineus
2 adductor longus
3 adductor magnus
4 gracilis
5 fibularis longus
6 extensor digitorum longus
7 tibialis anterior
8 fibularis (peroneus) brevis
9 rectus femoris (one of the quadriceps)
10 vastus lateralis (one of the quadriceps)
11 biceps femoris
12 soleus
13 vastus medialis (one of the quadriceps)
14 gluteus medius
15 tensor fasciae latae
16 gastrocnemius
17 sartorius

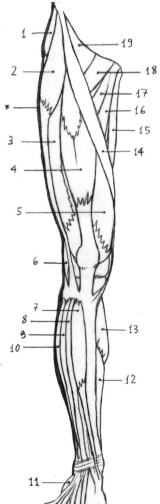

Diagram of right lower limb muscles in frontal view:
* The thick, dark outline shows the thickness of skin and subcutaneous layers.
1 gluteus medius
2 tensor fasciae latae
3 vastus lateralis (one of the quadríceps)
4 rectus femoris (one of the quadríceps)
5 vastus medialis (one of the quadríceps)
6 biceps femoris
7 tibialis anterior
8 extensor digitorum longus
9 fibularis longus
10 soleus
11 extensor digitorum brevis
12 soleus
13 gastrocnemius
14 sartorius
15 gracilis
16 adductor longus
17 adductor brevis
18 pectineus
19 iliopsoas (psoas major and iliacus)

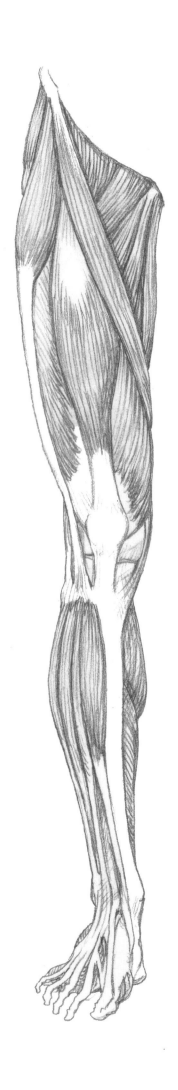

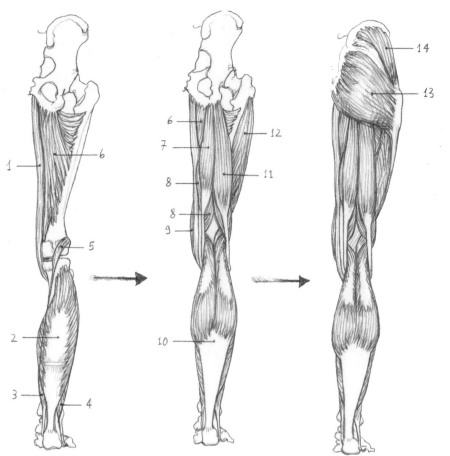

Tonal diagrams of relevant lower limb muscles in dorsal view, from deep to superficial layers.
 1 gracilis
 2 soleus
 3 flexor digitorum longus
 4 fibularis brevis
 5 plantaris
 6 adductor magnus
 7 semitendinosus
 8 semimembranosus
 9 sartorius
 10 gastrocnemius
 11 biceps femoris
 12 vastus lateralis
 13 gluteus maximus
 14 gluteus medius

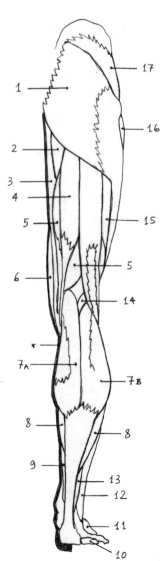

Diagram of lower right limb muscles in dorsal view:
* The thick, dark outline shows the thickness of skin and subcutaneous layers.
 1 gluteus maximus
 2 adductor magnus
 3 gracilis
 4 semitendinosus
 5 semimembranosus
 6 sartorius
 7 gastrocnemius: medial head (A) and lateral head (B)
 8 soleus
 9 flexor digitorum longus
 10 abductor digiti minimi (also occurs in the hand)
 11 extensor digitorum brevis
 12 fibularis longus
 13 fibularis brevis
 14 plantaris
 15 vastus lateralis (one of the quadríceps)
 16 tensor fasciae latae
 17 gluteus medius

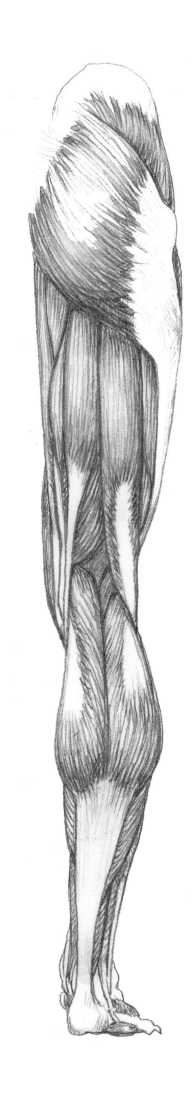

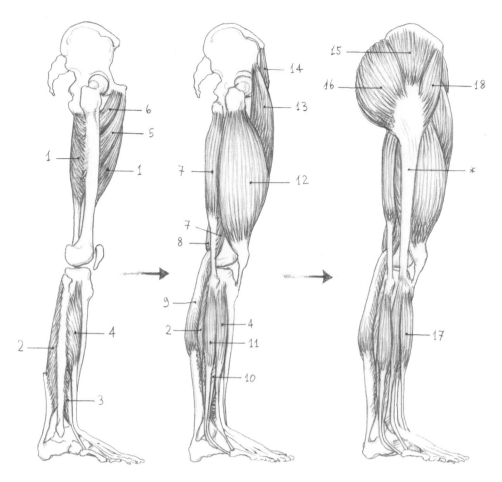

Tonal diagrams of relevant lower limb muscles in dorsal view, from deep to superficial layers.

1 adductor magnus
2 soleus
3 fibularis tertius
4 extensor digitorum longus
5 adductor longus
6 pectineus
7 biceps femoris
8 semitendinosus
9 gastrocnemius
10 fibularis brevis
11 fibularis longus
12 vastus lateralis
13 rectus femoris
14 sartorius
15 gluteus medius
16 gluteus maximus
17 tibialis anterior
18 tensor fasciae latae
* Fascia lata, which helps stabilise and steady the knee and hip joints.

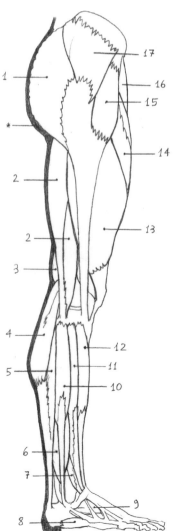

Diagram of lower limb muscles in lateral view:
* The thick, dark outline shows the thickness of skin and subcutaneous layers.

1 gluteus maximus
2 biceps femoris (long and short heads)
3 semimembranosus
4 gastrocnemius
5 soleus
6 fibularis brevis
7 fibularis tertius
8 abductor digiti minimi
9 extensor digitorum brevis
10 fibularis longus
11 extensor digitorum longus
12 tibialis anterior
13 vastus lateralis
14 rectus femoris
15 tensor fasciae latae
16 sartorius
17 gluteus medius

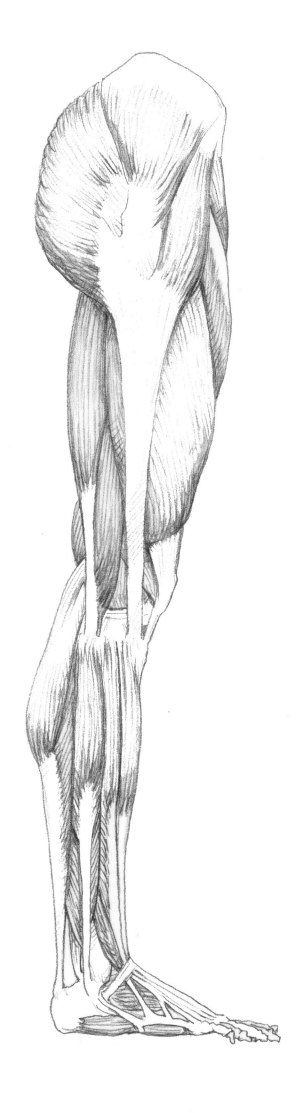

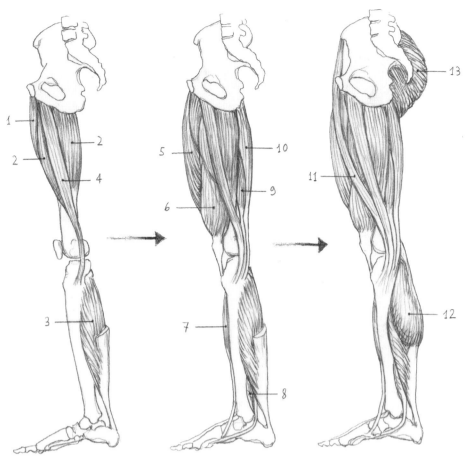

Tonal diagrams of relevant lower limb muscles (medial view), from deep to the superficial layers.

1 adductor longus
2 adductor magnus
3 soleus
4 gracilis
5 rectus femoris
6 vastus medialis
7 tibialis anterior
8 flexor digitorum longus
9 semimembranosus
10 semitendinosus
11 sartorius
12 gastrocnemius
13 gluteus maximus

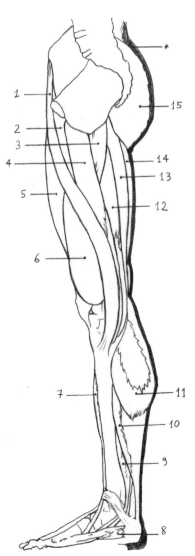

Diagram of lower limb muscles (medial view):
* The thick, dark outline shows the thickness of skin and subcutaneous layers.

1 sartorius
2 pectineus
3 adductor magnus
4 gracilis
5 rectus femoris
6 vastus medialis
7 tibialis anterior
8 abductor hallucis
9 flexor digitorum longus
10 soleus
11 gastrocnemius
12 semimembranosus
13 semitendinosus
14 biceps femoris
15 gluteus maximus

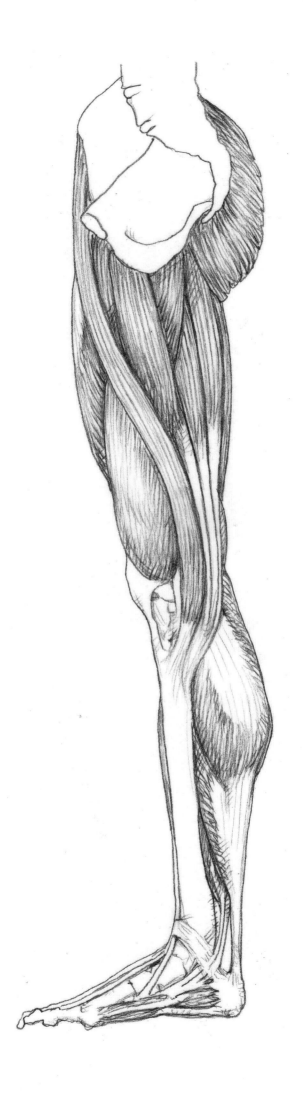

The usefulness of anatomical study cannot be underestimated if understood as a tool to gain knowledge, a source of inspiration, a means of interpretation …

Painting of a sculpture by Auguste Rodin (*L'Ombre* (1880–1898), bronze, 192cm (75¾in), Paris, Musée Rodin) worked in oil on prepared canvas, 20 × 30cm (7¾ x 11¾in), 2013.